HUNTINGDONSHIRE
THROUGH TIME
Alan Akeroyd &
Caroline Clifford

AMBERLEY PUBLISHING

Acknowledgements

The old photographs in this book have all come from the collections held at Huntingdon Library and Archives, where they are freely available for consultation alongside many thousands of other historical documents, maps, and published resources. Huntingdon Library and Archives is a Cambridgeshire Libraries service, provided by Cambridgeshire County Council. A copy of this book, annotated to show the original document reference numbers, is available at Huntingdonshire Archives. If you would like to see or purchase a copy of any of the originals, please visit the Archives.

We would like to thank: Richard Wells, Headmaster of Kimbolton Prep School, for his assistance in taking one of the Kimbolton photographs; Bob Burn-Murdoch, Curator of the Norris Museum in St Ives; Soo Martin at the FenPast Scanning Bureau for her technical expertise; and all our colleagues at Huntingdon for the help and advice they have given us, in particular Lesley Akeroyd, Laura Ibbett, and Esther Bellamy.

First published 2010

Amberley Publishing Plc
Cirencester Road, Chalford,
Stroud, Gloucestershire, GL6 8PE

www.amberley-books.com

Copyright © Alan Akeroyd and Caroline Clifford, 2010

The right of Alan Akeroyd and Caroline Clifford to be identified as the Authors of this work has been asserted in accordance with the Copyrights, Designs and Patents Act 1988.

ISBN 978 1 84868 713 4

British Library Cataloguing in Publication Data.

A catalogue record for this book is available from the British Library.

Typeset in 9.5pt on 12pt Celeste.
Typesetting by Amberley Publishing.
Printed in the UK.

Introduction

Huntingdonshire has always been a mainly rural area, with its economic fortunes largely dependent on the major roads and waterways which run through it. The River Great Ouse, which runs through or past the market towns of St Neots, Godmanchester, Huntingdon and St Ives, was the most important factor in Huntingdonshire's early history. All four of these towns originated in Roman or Saxon settlements, and during the course of the Middle Ages they competed with each other for rights to fairs and commercial trade. Ramsey was geographically isolated from the other towns, being in the Fens, but it was the home of a powerful abbey which owned land and mills throughout the county.

Two major roads linking London with the north crossed the Great Ouse in Huntingdonshire, namely the Great North Road (the predecessor of what is now the A1) and the Old North Road, which largely followed the route of the Roman Ermine Street. Both routes carried a great deal of stagecoach traffic during the heyday of the turnpike system, and indeed one high point of Huntingdonshire's economic development occurred during the Georgian period, when long distance stage and mail coaches stopped overnight in Huntingdon's coaching inns. This particular boom drew to an end during the nineteenth century when the coming of the railways took business away from the old inns, but Huntingdonshire's urban industries soon took advantage of the railway network. St Ives became home to the manufacture of steam traction engines, while St Neots specialised in gas engineering and Huntingdon became known for carriage works. Outside of the towns, in the villages, the work remained largely agricultural.

Huntingdonshire always had a fairly small population; during the nineteenth century only Rutland was smaller. Nevertheless, the county has played an enormous part in British history. Oliver Cromwell was born in Huntingdon in 1599 and lived there until moving to St Ives in 1631, and from there to Ely in 1636; other members of the Cromwell

family owned substantial properties throughout the county. Other famous people associated with Huntingdonshire include the diarist Samuel Pepys, car manufacturer Henry Royce, and former Prime Minister John Major. Huntingdonshire is also widely associated with the invention of the international sport of bandy, which was originally played on Huntingdonshire's frozen rivers during the nineteenth century. Another distinction for Huntingdonshire was its selection as the county to hold the first modern-style prisoner of war camp, which was created for prisoners captured during the Napoleonic wars. About five thousand French prisoners were held in the camp at Norman Cross, near Yaxley, during the period 1797-1814.

None of Huntingdonshire's towns grew very much during the twentieth century and it became apparent that, with Peterborough situated just across the county's north western border and Cambridge just across its south eastern, Huntingdonshire's days as an independent county were numbered. In 1965, Huntingdonshire and Peterborough joined to form a single county, and in 1974 this in turn was amalgamated with Cambridgeshire to form a single and much larger county authority. In 1998, Peterborough was separated again, but Huntingdonshire itself remains today as a district within Cambridgeshire.

True to its history, modern Huntingdonshire is still very dependent on its transport links with the rest of the country. As you look at the photographs in this book you will see that horses have been replaced by cars, that the roads have become busier, and that even some entire buildings have been replaced by junctions or car parks, but the underlying flow of history is still the same.

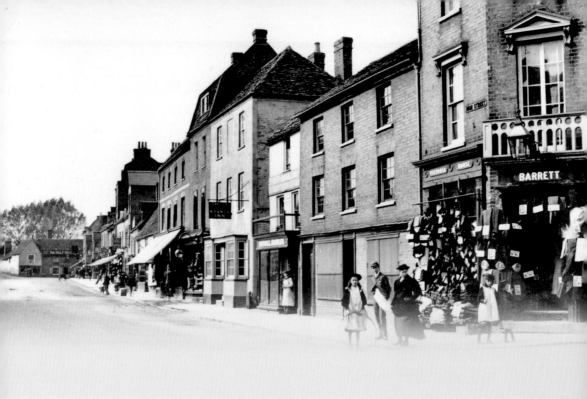

Part One

The Towns

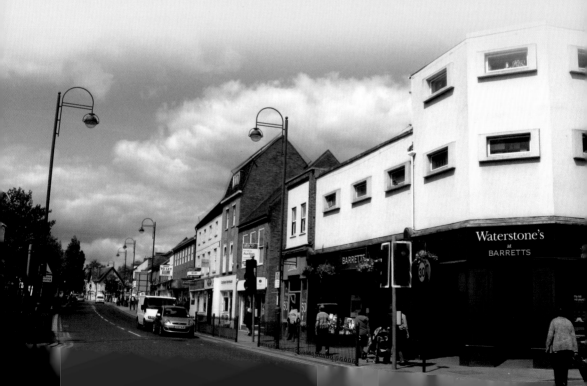

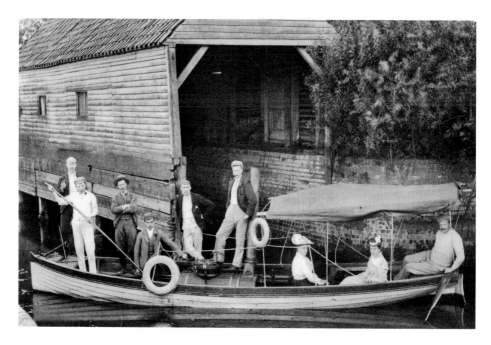

Godmanchester – the Chestnuts

The Chestnuts is a timbered building constructed in 1873 in the Tudor style. It was owned at one time by Sir William Prescott, Sheriff of Huntingdonshire. By the 1960s it had been taken over by the County Council and since then it has been extensively altered and enlarged to provide sheltered flats. The houses along West Street back onto the river, and the photograph is of the Chestnuts boathouse in 1912. The boathouse has now disappeared.

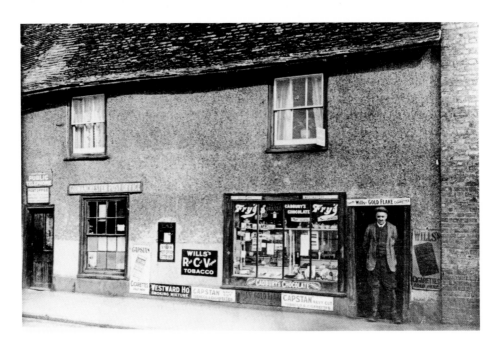

Post Office

This was probably the post office in Godmanchester. In 1914, there were three postal deliveries a day and one on a Sunday. Mail was collected five times a day and twice on Sundays; a far cry from the service these days. The building is now a private residence.

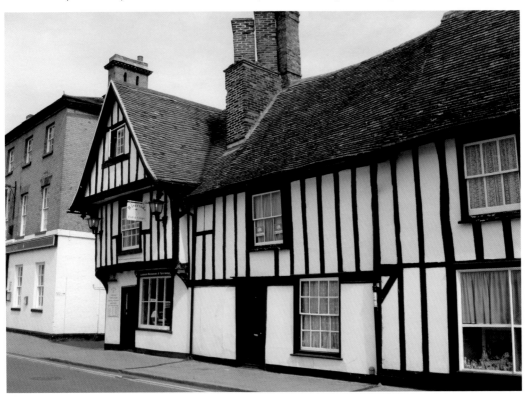

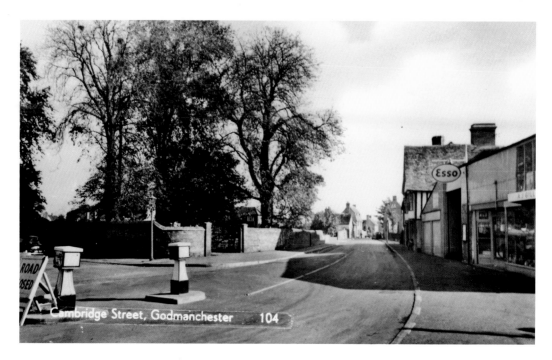

Cambridge Street, Godmanchester 104

Cambridge Street

These photographs of Cambridge Street in Godmanchester are taken at the junction with The Causeway and Post Street. The garage on the left has been replaced with mock Tudor houses. A mini roundabout has recently been installed to control the ever increasing amount of traffic.

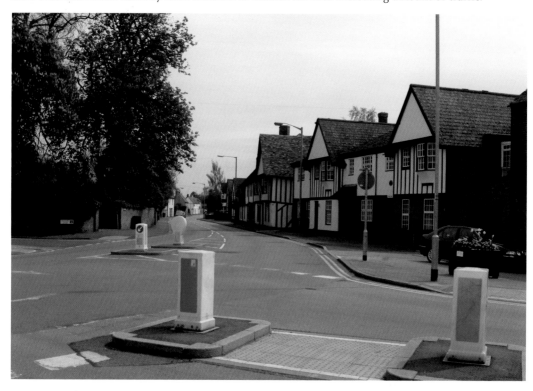

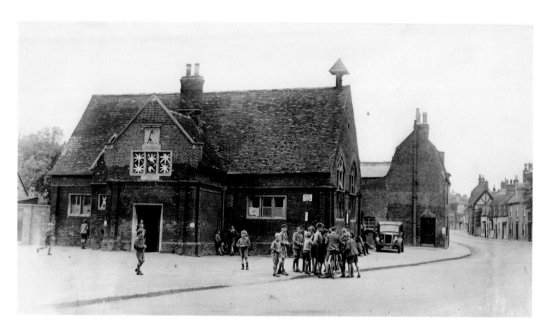

Queen Elizabeth School

The Godmanchester Grammar School was founded in 1561 following a bequest from Richard Robins and a charter from Queen Elizabeth I. It remained a boys school until 1948. The older photograph was taken in 1944, not long before it closed. The building is now used as a community room.

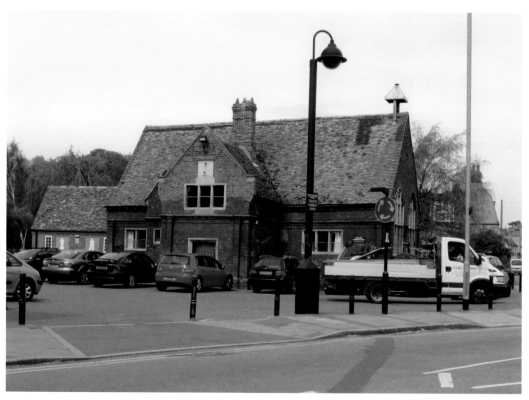

Godmanchester Baptist Chapel

The Particular Baptist Chapel was built in 1815; it later had a Sunday school attached and a burial ground situated in front. During Victorian times, public baptisms took place in the River Ouse. The chapel has been demolished; all that remains is a garden of rest which still contains traces of the burial ground.

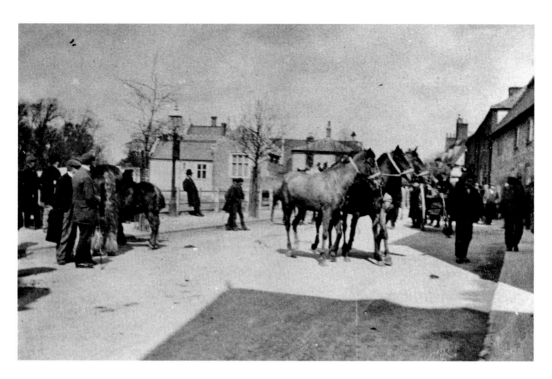

The Causeway

The old photograph shows a horse fair in Godmanchester's Causeway. Horses have long since given way to cars, with many people stopping to feed the many ducks found on this wide section of the river. The Chinese bridge you can see in the modern photograph was originally built in 1827. It has been rebuilt and refurbished many times, most recently in 2010.

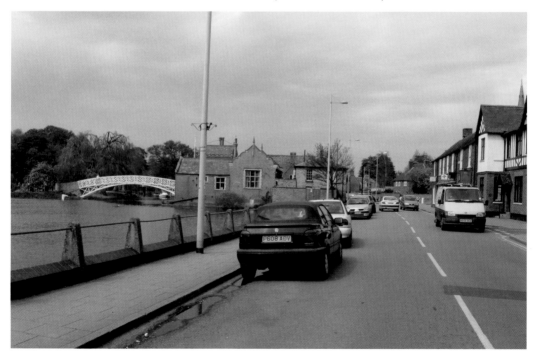

Huntingdon Flour Mill

Potto Brown's steam mill was built in 1861, just behind the hosiery mill on the Godmanchester side of the river. Potto was a leading non-conformist and had a chapel attached to the mill for the spiritual welfare of the workforce. The Brown and Goodman flour mill was demolished in 1969. It took 100 lbs of TNT to bring the seven storey mill down.

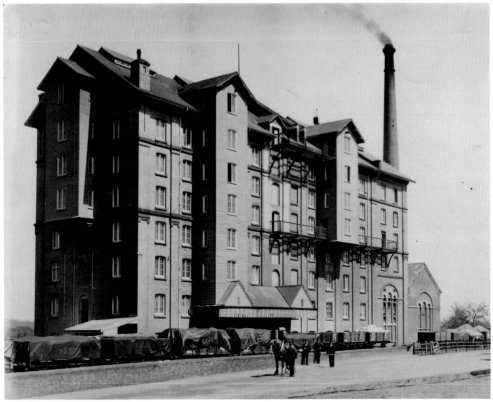

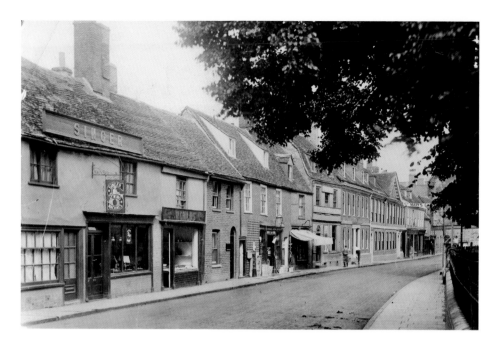

Singer Shop

This view was taken in the 1930s, but the Singer sewing shop had been in business in Huntingdon since before the First World War. The shop finally closed in October 2009 with the retirement of the owner, Patrick Moore, aged eighty-one. He had worked at the shop since 1960; first as manager, then as owner.

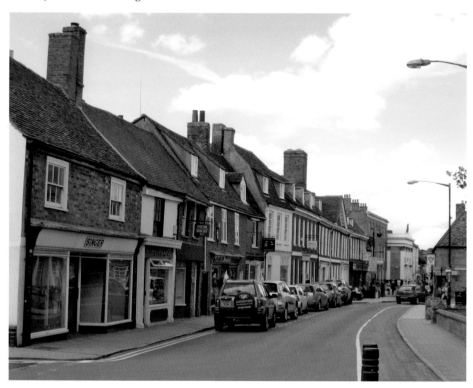

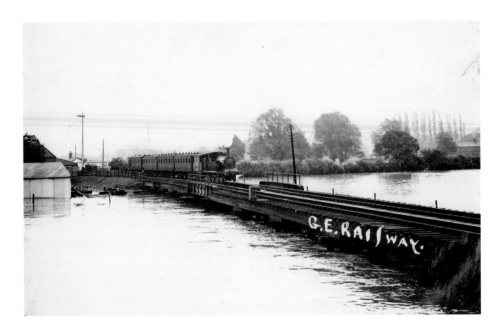

The Railway Bridge

The Great Eastern Railway line ran from Huntingdon to Cambridge. A wooden trestle bridge carried the railway across the River Ouse and its flood plain. The 1910 picture shows the river in flood. The bridge was not robust and was subject to speed and weight restrictions. Occasionally it would be set on fire by the sparks thrown out by the locomotives. The line was closed in 1959, and the bridge was replaced by the Huntingdon bypass (later the A14).

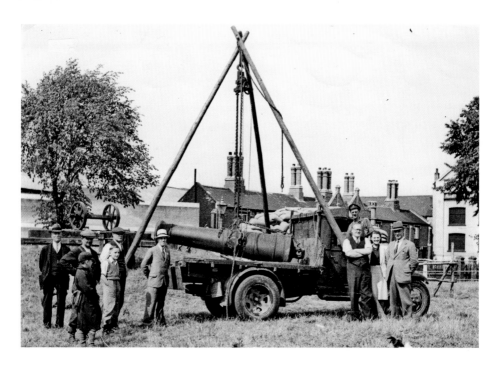

The Sebastopol Cannon

One hundred and fourteen members of the 31st Huntingdonshire Regiment died at Sebastopol and were commemorated by the installation of a captured Russian gun on Mill Common next to the County Hospital. There is no record of how the gun came to be in Huntingdon, but a similar one in Ely was presented by Queen Victoria. During the Second World War, it was removed and used for scrap metal. A fibreglass replica of the cannon copied from the cannon at Ely was installed and unveiled by John Major, Prime Minister and local MP, during the first Gulf War in 1991.

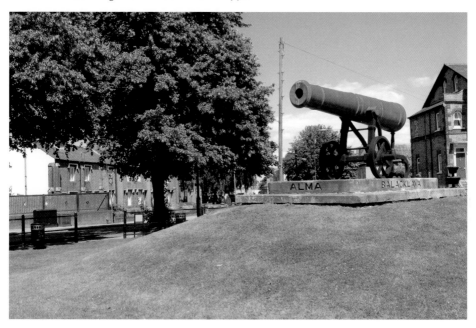

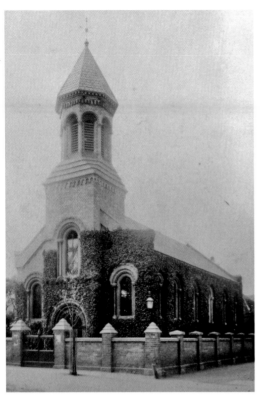

St John's Chapel

The chapel was built in 1845 on the site of the old Georgian theatre in Huntingdon. It was commissioned by local philanthropist Olivia Bernard Sparrow who wanted to see it used by the navies building the Great Northern Railway. Sadly, it ceased functioning within weeks of Lady Olivia's death. It later became the George Hall and was used as a decontamination centre during the Second World War. The building still remains, lying neglected.

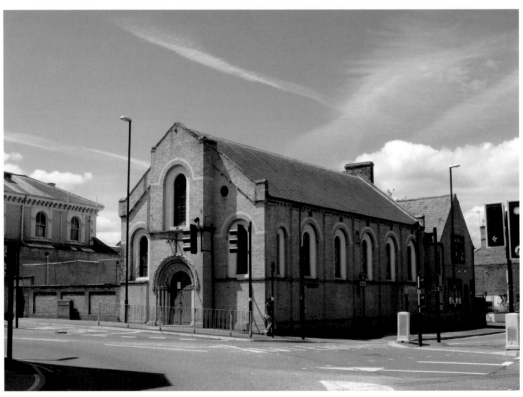

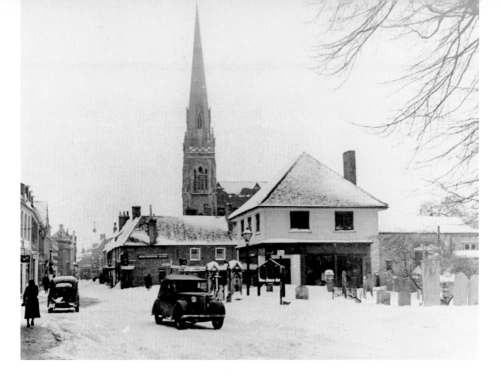

Huntingdon High Street

Looking north at the junction of Hartford Road, the corner was widened in the 1930s and St Mary's vicarage was demolished. The Three Tuns public house can be seen in both views, but the older picture is dominated by the 181 ft high tower of the Trinity Church, built in 1867. Unfortunately, the spire had very little in the way of foundations and the whole church had to be demolished in 1967. It was replaced by a Tesco supermarket.

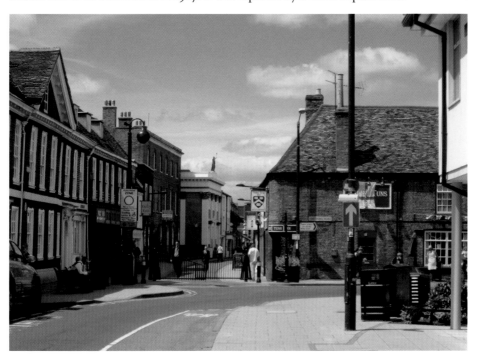

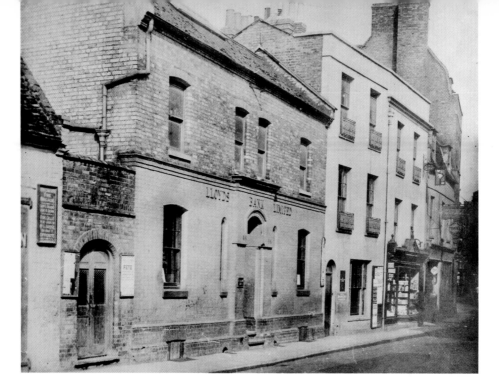

St Benedicts

Lloyds bank as it was in the early twentieth century. This building had previously been Huntingdon's police station. The gateway led to St Benedict's churchyard, a small walled garden preserved after the church itself was pulled down in 1802. This later became part of the St Benedict's Court shopping precinct, which opened in 1981.

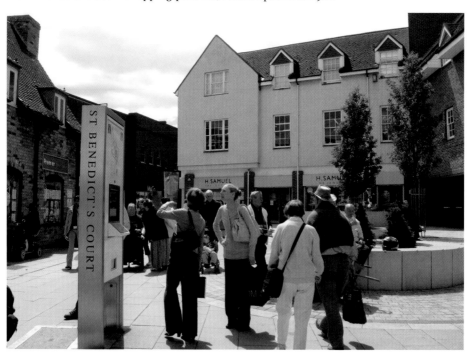

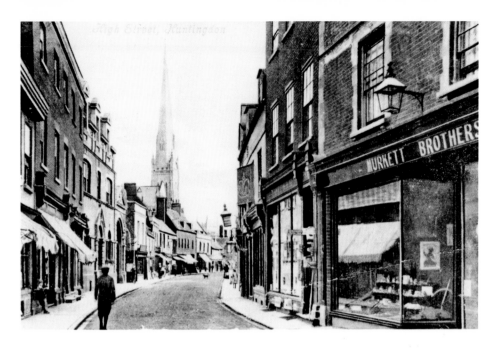

Murkett Brothers

The old photograph shows one of several premises owned by the Murkett brothers in Huntingdon. The first opened opposite St Mary's church in the 1890s. This shop in the High Street was housed in the former Walden School, where the Murkett brothers had been educated. In 1911, they purchased the old Fountain Hotel in the Market Square (currently the 99p shop) and branched out from bicycles into the motor trade. Subsequently, the company operated from premises on the ring road. The business relocated again when the Sainsbury's development began and it now trades in Stukeley Road.

Elphicks

Ernest William Elphick opened his shop at 52 High Street in 1903, selling everything from prams to household furnishings. The business moved to its current location in George Street in 1911. The area has been redeveloped as All Saints Passage.

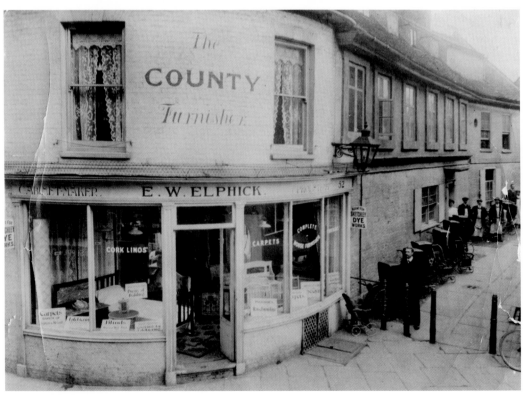

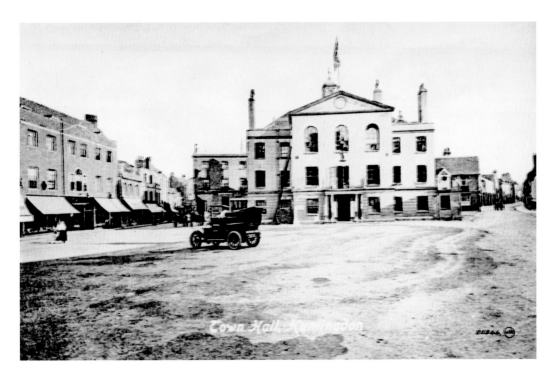

Huntingdon Market Hill

The old picture, *c.* 1900, shows Huntingdon Town Hall, built by public subscription in 1745. The white façade had been applied in 1784, but was removed before George VI's coronation celebrations in 1937. The modern photograph shows the 'Thinking Soldier' war memorial, sculpted by Lady Kathleen Scott, widow of Scott of the Antarctic, which was unveiled in 1923.

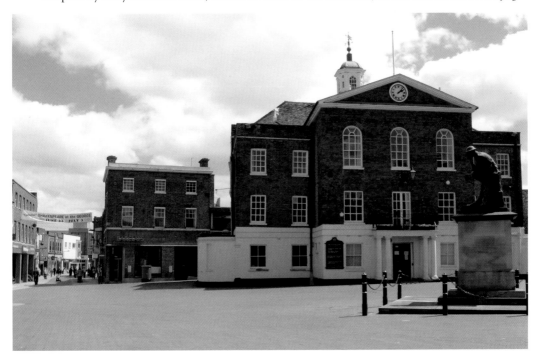

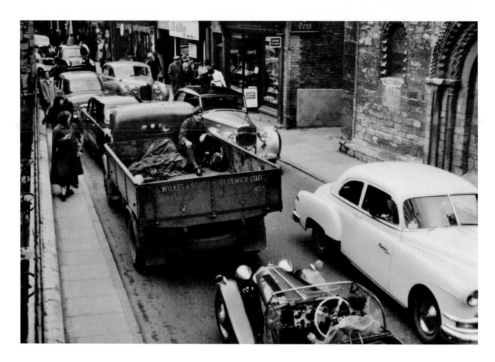

Huntingdon High Street (2)

When this photograph was taken in 1950 an astonishing 6,000 vehicles a day were travelling along the High Street. Traffic jams, like this one outside what is now the Cromwell Museum, were commonplace. It was not until the ring road opened in 1970 that shoppers were able to wander freely in the town centre.

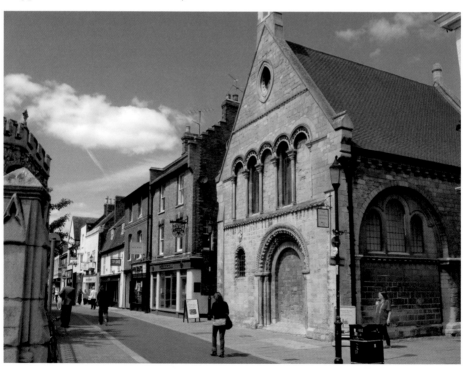

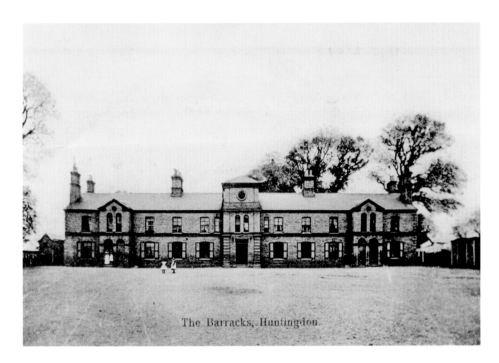

The Barracks, Huntingdon.

The Barracks

The Militia Barracks, like many buildings in Huntingdon, were designed by Victorian architect Robert Hutchinson. The barracks were the home of the King's 5th Rifle Regiment. There was a large parade ground at the front. Only one wing of the barracks survives today. It was incorporated into the Cromwell Square Residential Home which was built in 1969.

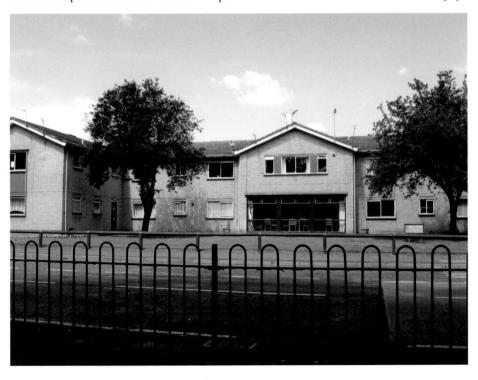

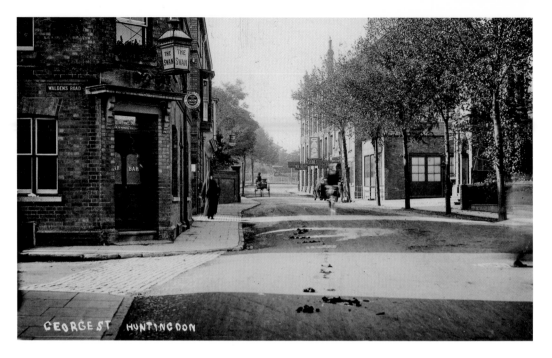

George Street

The Swan public house on the corner of George Street, *c.* 1920. On the right are the Windover Carriage Works, famous for making carriages for royalty. In 1930, the factory was taken over by Chivers, employing around 500 people, canning vegetables and later making jam. The factory closed in 1966. All that remains now is Sandford House, the former home of Charles Windover. This later became Huntingdon Post Office, but now stands empty.

Pathfinder House

When Huntingdonshire lost its status as a county in 1974, the new District Council needed accommodation. New offices were built in the grounds of Castle Hill House at a cost of £1.6 million. The building was named Pathfinder House in honour of the squadron based at Castle Hill House during the war. Unfortunately, only thirty years after the building opened in 1977, it had become unsafe. A new Pathfinder House, costing £16 million, was completed in May 2010.

The 'New' Grammar School

Huntingdon has had a Grammar School since 1565, but the town centre premises became too cramped. A new school was opened in Brampton Road just weeks before the outbreak of the Second World War. In 1970, the upper school moved to Hinchingbrooke and the school was united onto a single site at Hinchingbrooke in 1992. After being set alight by arsonists, the old school building was demolished and replaced by houses. Only the name 'Scholars Avenue' indicates that there was once a school there.

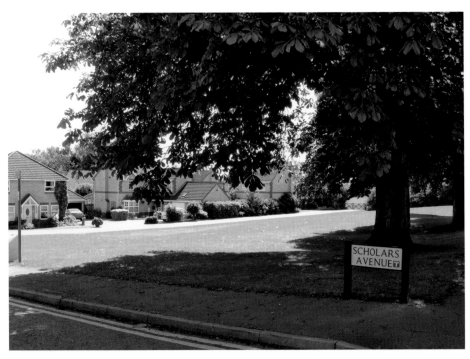

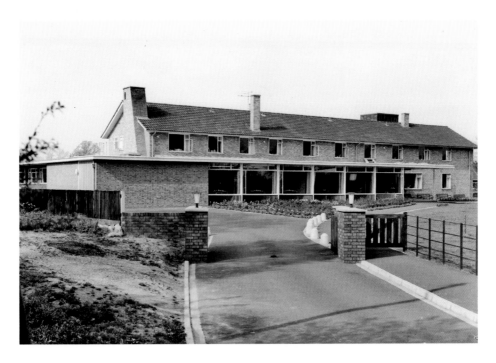

Hunters Down

The original Hunters Down was built in Huntingdon in the 1960s as a residential home for the elderly. Age and new regulations made the old building unsuitable and it was replaced with a new building which opened in 2008.

Huntingdon Library
Huntingdon branch library opened
in Gazeley House in 1954 with 1,679
members, issuing 2,200 books per week.
Two new buildings later, Huntingdon
now has a state of the art library and
archive building which opened in
2009. The library now has over 29,000
registered members.

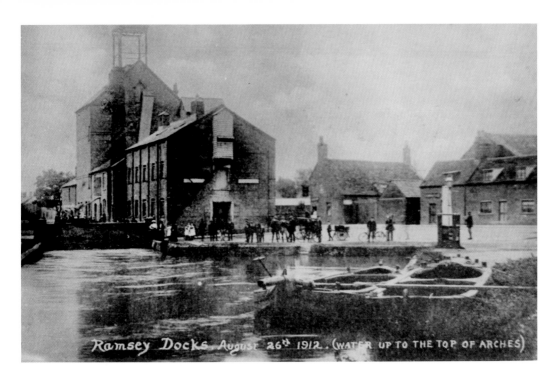

Ramsey Docks August 26th 1912. (WATER UP TO THE TOP OF ARCHES)

Ramsey Docks

The Mill was built in 1871 as a storehouse for goods brought in by barge to Ramsey Docks. Barges were replaced by the railway and the mill was converted by Tom Flowers into a flour mill. It was later a potato store and grain drying plant. The old photograph shows the mill during the floods of 1912. The mill has been refurbished again and converted into flats which were opened by local MP and future Prime Minister John Major in 1983.

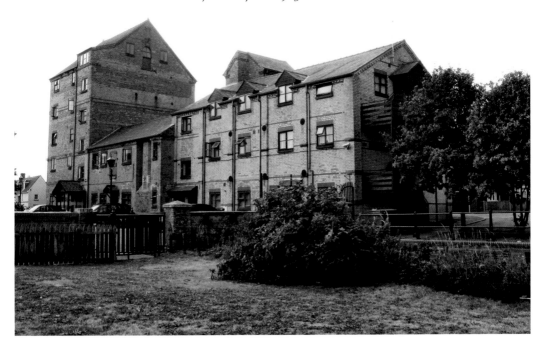

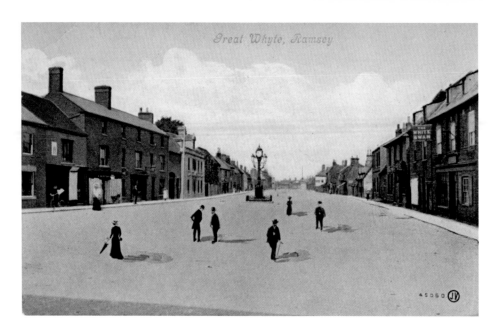

The Great Whyte

The Great Whyte is one of the widest streets in the region – over twenty-five metres wide. Originally, a stream called Bury Brook ran though Ramsey, with roads on either side. The stream was covered over, but still runs underneath in a tunnel running from the mill to a culvert underneath the NatWest bank. The clock on the Great Whyte dates from the 1880s and was once powered by the water that runs underneath. It was converted to electricity in 1920.

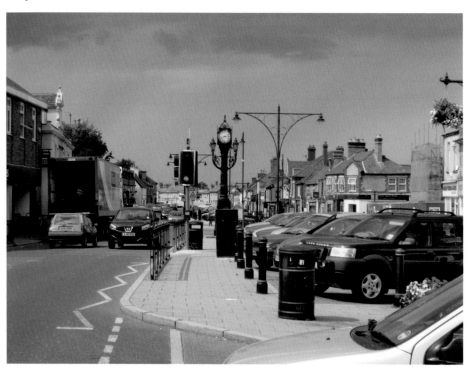

Biggin Lane

Biggin Lane, in 1912, shows no sign of habitation, although the name 'Biggin' or 'Bigging' means building or outhouse. Today, however, houses line the lane which has been swallowed up as Ramsey expands.

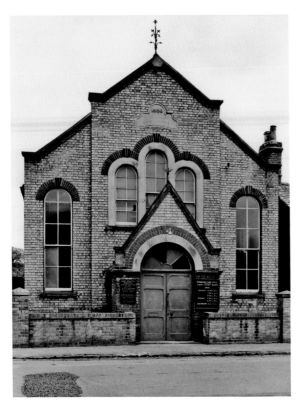

Ramsey Library

The former Methodist chapel in Newtown Road was converted into Ramsey's first library. This was replaced by a purpose built library in School Lane in 1964. The newer building itself will soon be replaced by a third library on the site of the former cinema. Today, there is no sign that a chapel ever occupied the site in Newtown Road.

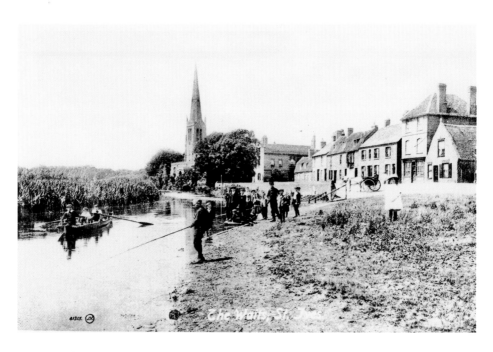

St Ives – The Waits

The muddy slope down to the river was an ideal place for children and animals to use the river. In the 1890s, boats were hired out from this area – you can see one on the river. Between the two world wars the area was raised up to give a grassy area with flowerbeds. In 2006-7, brand new flood walls were installed, complete with metal floodgate. You can see St Ives parish church and Holt Island in the background.

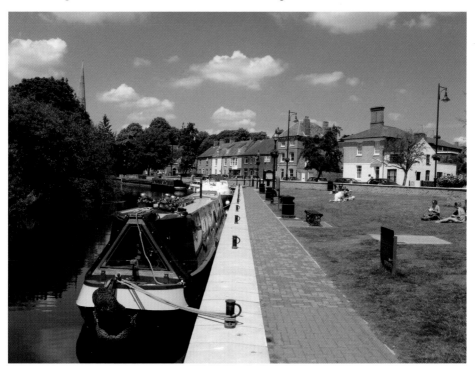

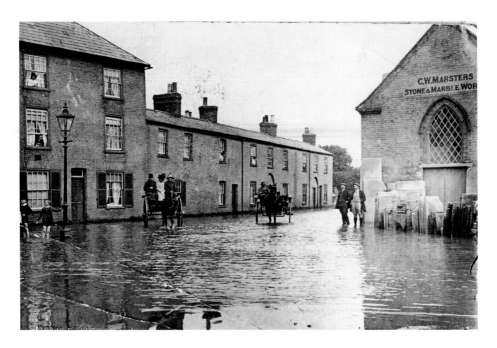

Globe Place

This photograph, taken during the disastrous floods of August 1912, shows one of several streets of Victorian cottages which were demolished in the 1960s to be replaced by the Globe Place car park in St Ives. The stonemason's premises were once a chapel for the Swedenborgians or New Jerusalem Church. This stood next to the existing building, the Primitive Methodist Chapel, which you can see in the new picture.

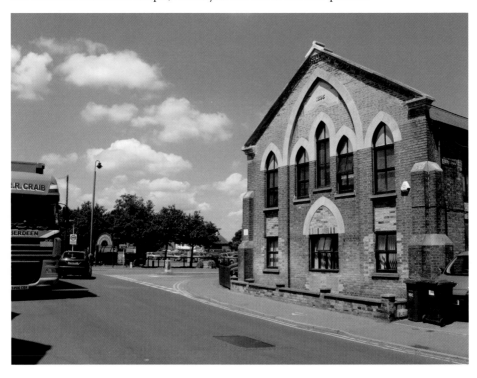

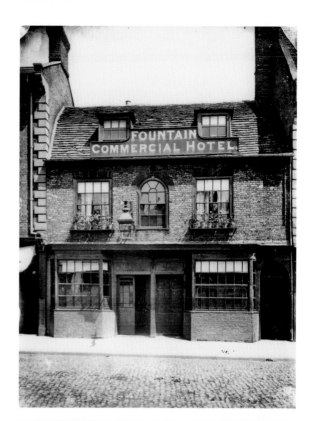

The Fountain Inn

The Fountain Inn on the Pavement in St Ives was one of many which benefitted from the market trade. It closed in 1909 and has been a bakery and café ever since. Although the ground floor has been substantially altered, the upper floors are still recognisable.

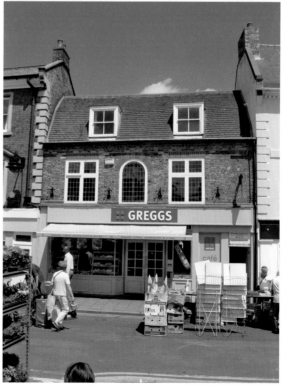

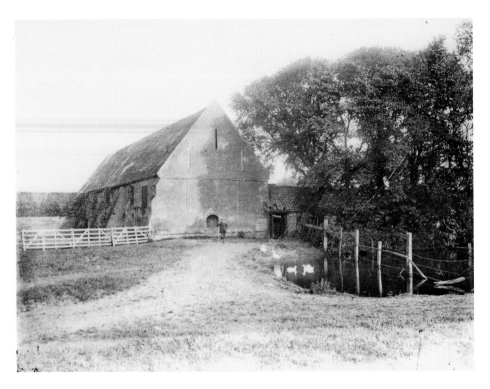

Cromwell's Barn

The barn at Green End Farm in St Ives was probably built of local red brick during the reign of Queen Elizabeth I. It was known more recently as Cromwell's Barn as, according to legend, Oliver Cromwell drilled his troops there. The barn was demolished in the 1960s. The site is now home to small industrial units.

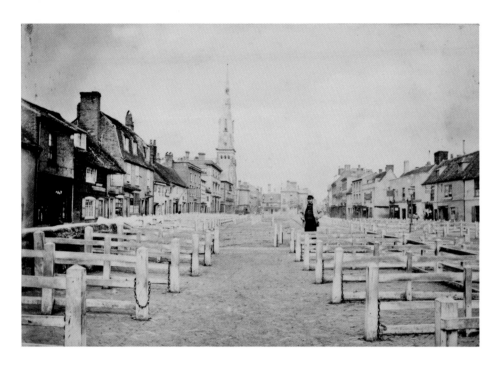

Market Hill, the Sheep Market

St Ives has long been famous for its market. Since the first market charter 900 years ago, animals were sold on the streets of St Ives. Before new metal pens were installed, most of the street was covered with wooden pens to hold the sheep. The only relic of the sheep market is the wide pavement where the sheep pens used to be where today's markets are held.

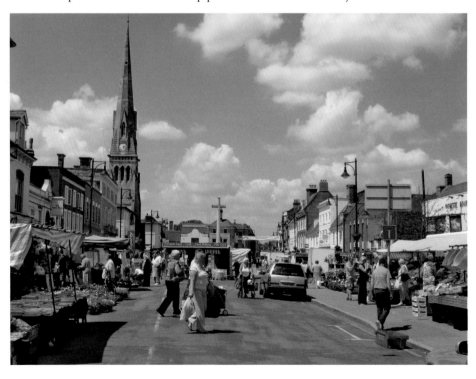

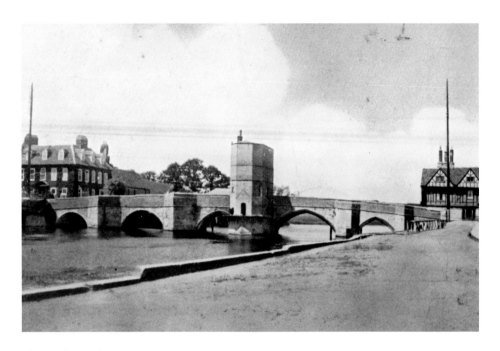

The Bridge and Quay

The Ouse was once a working river with cargoes of coal arriving from Kings Lynn at the Town Quay. With the coming of the railways barge traffic ceased and the quay became quiet. The chapel on St Ives Bridge became a private house in the 1730s when two extra storeys were added. They were removed in 1930 and the chapel restored to the way it had looked in medieval times.

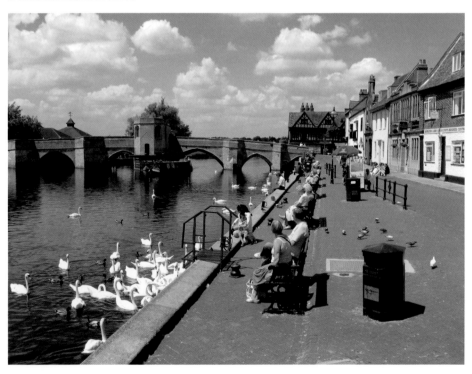

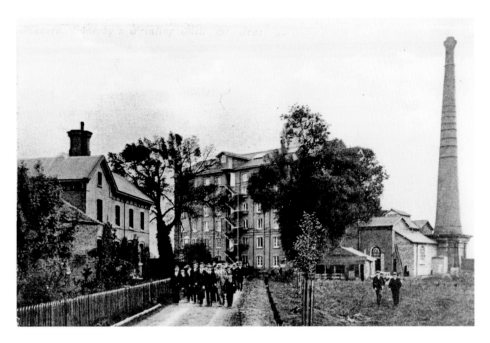

Enderby's Mill

Built in 1854 by Brown and Goodman for processing corn, the former steam mill in St Ives still stands, converted into riverside flats and without its chimney. When this photograph was taken it was Enderby's printing works, but later became the home of Sinclair Radiotronics, the home of many innovations in electronics.

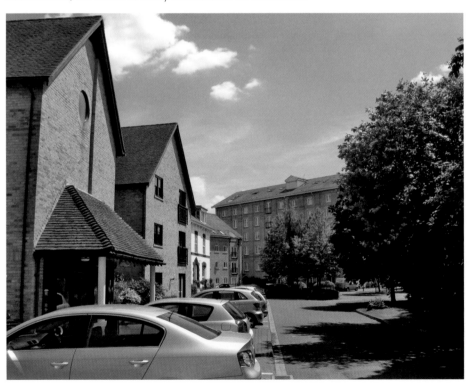

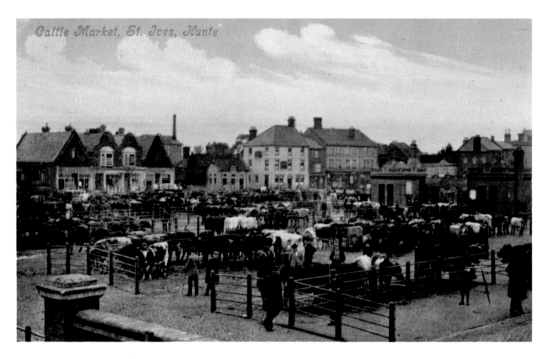

Cattle Market, St. Ives, Hunts

St Ives Cattle Market

Cattle used to be sold in the Broadway, but in 1886 new markets were built at the east end of town to move the animals off the streets. The new metal cattle pens were conveniently close to the railway station. After the livestock market closed, the bus station was built on the site in 1985. The original lodges you can see in the background now serve as a gateway to the bus station.

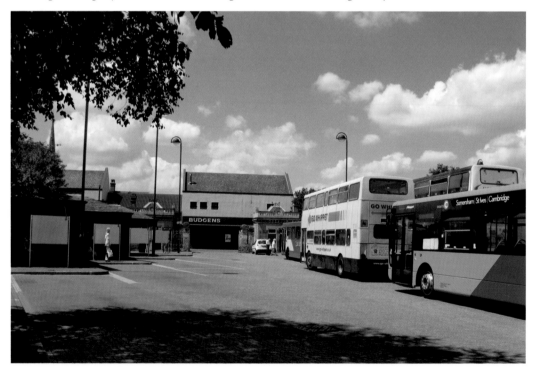

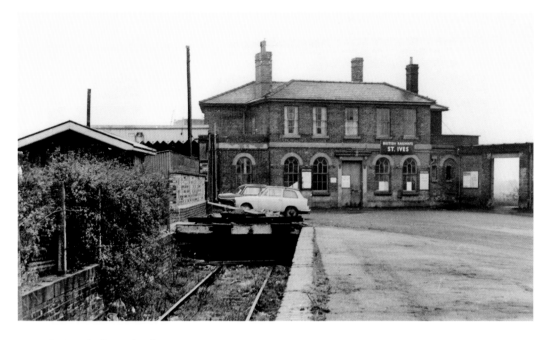

St Ives Railway Station

At one time you could travel by train from St Ives to Cambridge, Wisbech, Huntingdon and beyond. The station had three platforms and seven waiting rooms, but it was demolished in 1977 soon after this photograph was taken. In 1980, the St Ives bypass was built right across the site. All that is left is the former Railway Hotel, which closed in 1951. Forty years later, passengers will once more travel this way on the guided bus.

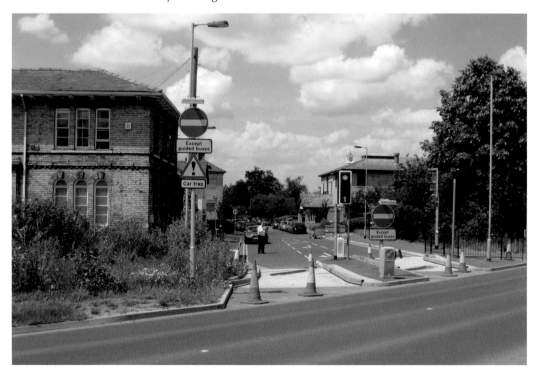

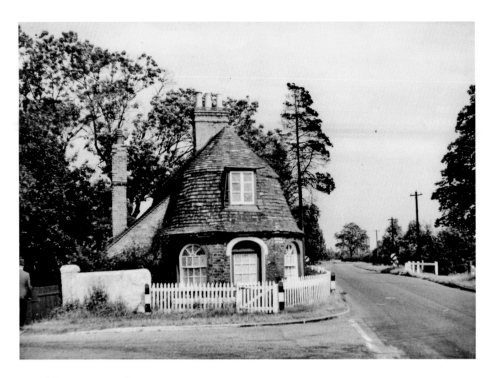

Republic Cottage Toll House

It was said the cottage received its name because it stood on the parish boundary between St Ives and Holywell-cum-Needingworth, and the resident refused to pay rates to either. In truth, the owner Henry How gave the cottage its name in the 1880s because he opposed the monarchy and favoured a republic. Republic Cottage stood on the St Ives to Somersham turnpike. It was demolished in 1968 when the dangerous junction was widened. A roundabout has since been put in.

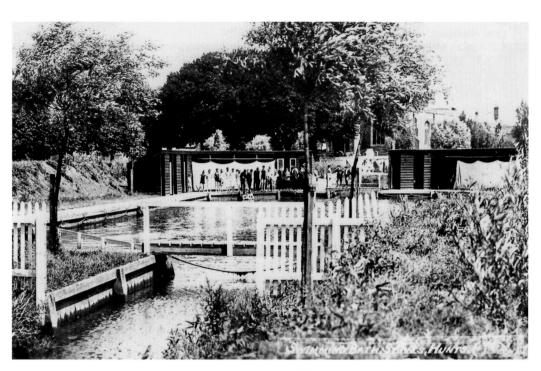

The Bathing Place

The people of St Ives traditionally swam in the river, but this could be dangerous. In 1913, a shallow basin was dug on Ingle Holt, an island in the River Ouse just opposite the Norris Museum. The pool was eight sided, with changing sheds and a water polo goal. The pool closed in 1949 and St Ives did not get another until 1970. Holt Island, as it is called these days, is now used by the Sea Scouts.

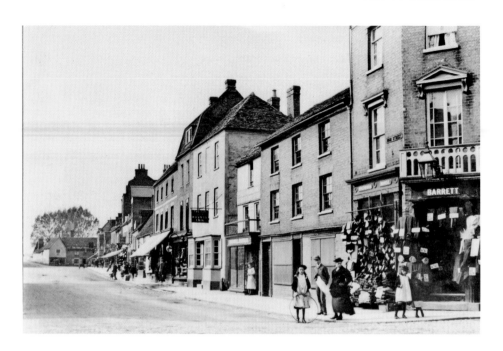

St Neots – North side of the Market Square

Traditionally the north side of the Market Square was the shopping side, as it received more sun for the craftsmen to work in their shops. The original shops would have been built up against the walls of the Priory. These views, looking towards the bridge and the Half Moon (now Bridge) Hotel, show Barretts, clothier and outfitter since 1888. Barretts is still trading and now includes a branch of Waterstone's.

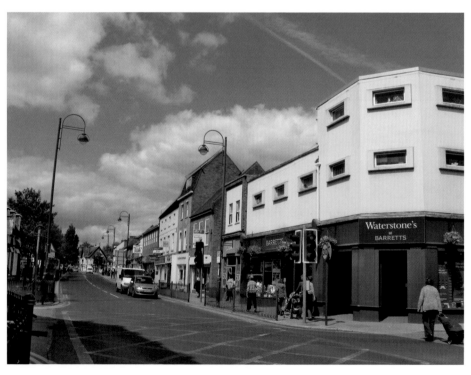

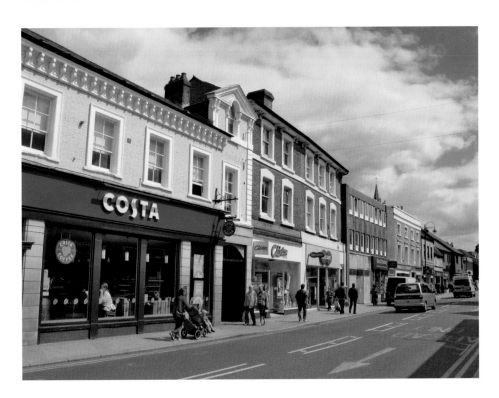

1947 Floods

March 1947 saw the worst floods in St Neots for 100 years; almost 800 houses were affected. Military vehicles were brought in to deliver supplies to people trapped above the shops. International Stores in the High Street is now Costa Coffee.

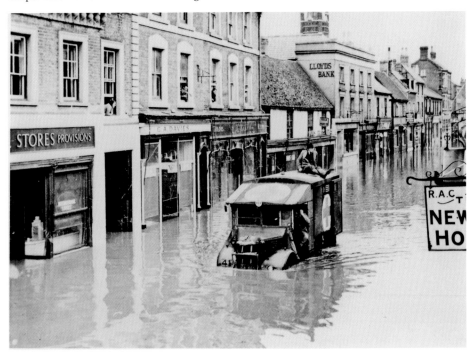

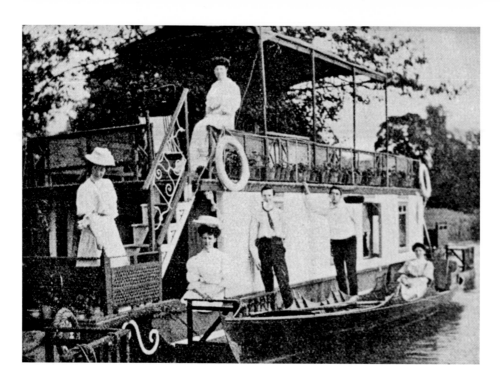

Houseboats

Charles Gill, a St Neots furniture maker, turned his hand to making houseboats. The first of these, *The Ouse Lily*, was launched in 1901 from premises hired at the corner where Hen Brook joins the river. There were pavilions on shore and in summer he arranged riverside concerts lit by Chinese lanterns. Houseboat holidays on the Ouse became popular with Londoners. Boating is still a popular pastime in this area of town.

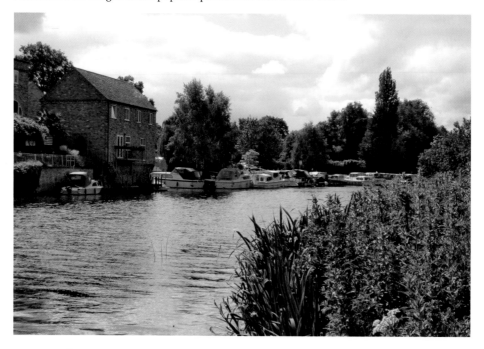

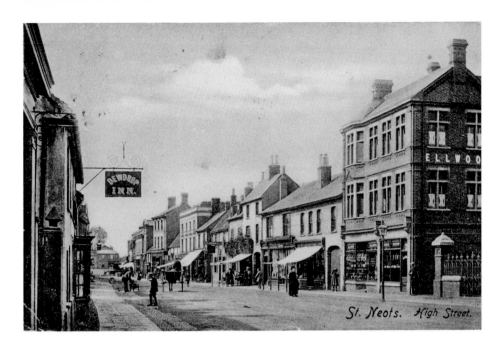

St Neots High Street

Thomas Ellwood, a boot upper manufacturer, currier and leather merchant, bought this site in 1886 to enlarge his business by building a new factory and warehouse. His initials T. E. and the date 1890 can still be seen on the side facing the High Street. After 1908 the building became a bank, latterly the NatWest.

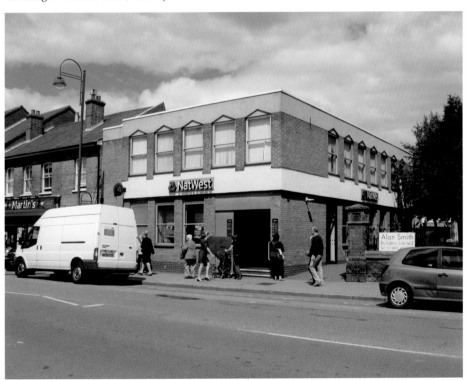

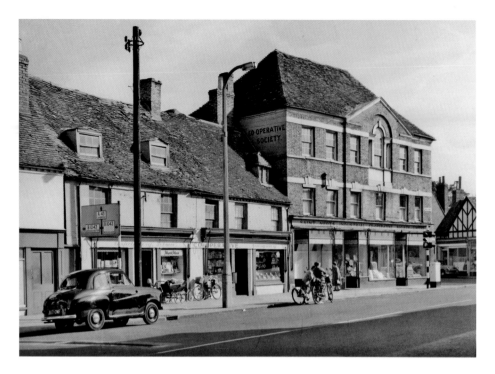

St Neots High Street (2)

This building, on the corner of Huntingdon Street, was built by the bell founder Joseph Eayre and is the site of the former George Inn and assembly rooms; visited, it is said, by John Wesley. The building was bought by the Co-operative Society in 1913. The premises are still owned by the society, now known as Westgate.

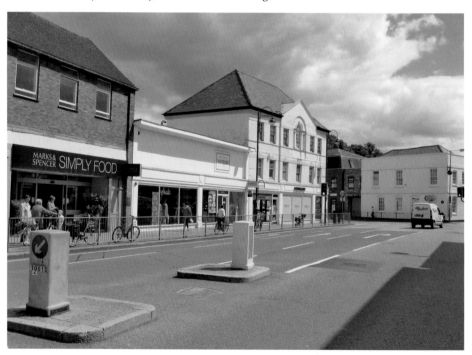

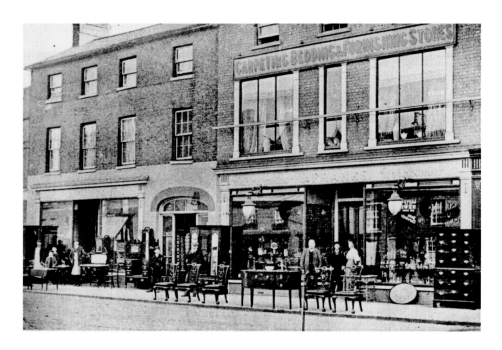

58/60 High Street

There has been a furniture shop here since J. Franks opened in 1897 in purpose-built premises, replacing about five houses which had been mainly used as shops. John Franks, who became a wealthy furniture dealer, started out as a pedlar carrying a basket of goods for sale around on foot. In 1922, the shop became Brittains which moved here from 25 High Street.

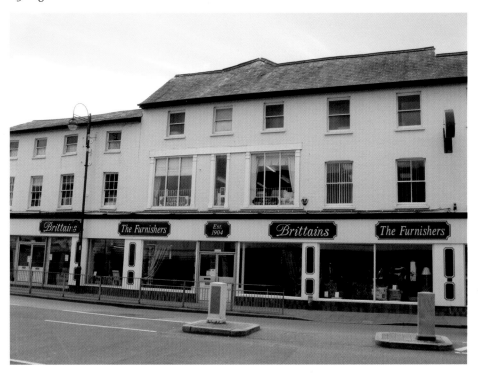

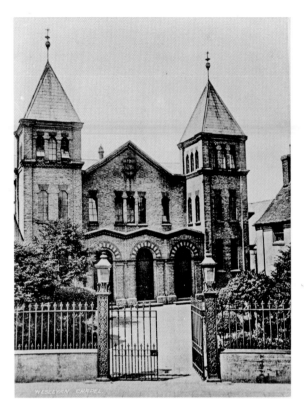

Huntingdon Street

The Wesleyan chapel stood on the west side of Huntingdon Street in St Neots, between the current Westgate building and the Sun Inn. Built in the 1790s, it was later demolished. Part of the site is now occupied by Anglia Co-operative Funerals.

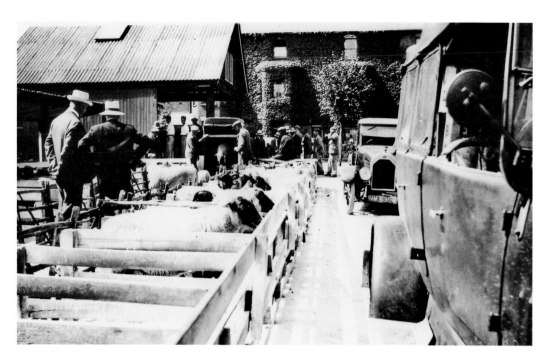

St Neots Auction Yard

This is one of two auction yards formerly in New Street, one of which may be the site of an old parish workhouse. Auctions have been held here since the 1860s. One of the former auction yards has been replaced by flats known as 'Old Market Court', while the other is still in operation.

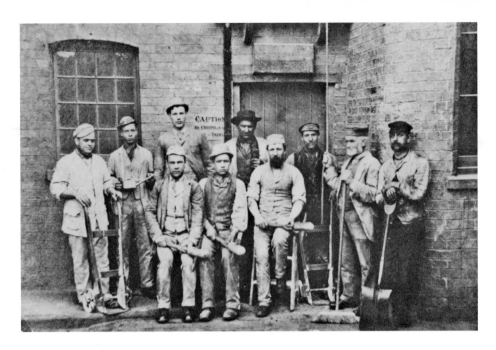

Paine's Mill

William Paine was a successful businessman in the Victorian era, but after the 1870s he concentrated on his milling and brewing business. This old photograph shows staff at his mill in Bedford Street, St Neots, taken around 1900. In 1910, the mill was totally destroyed by fire and the present mill built in its place. The building, now called Paine's Mill Foyer, has been converted and provides affordable accommodation for up to nineteen young people between the ages of sixteen and twenty-five.

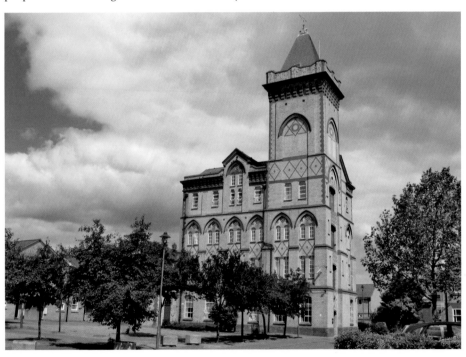

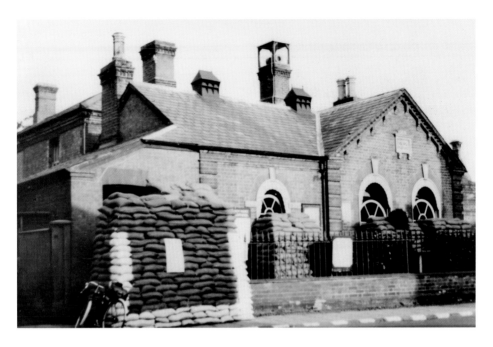

St Neots Police Station

The police station and magistrates' court were built in New Street, a few years after the Hunts county police force was founded in 1856. The old photograph shows it sandbagged during the Second World War when it was used as the Headquarters of the ARP. The building is now the St Neots Museum.

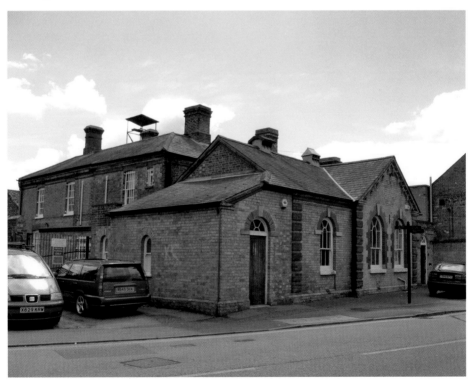

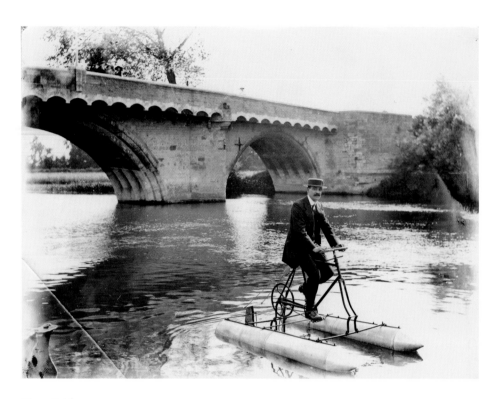

River Bridge

The older photograph is of Mr Rowell on his water-cycle, with the St Neots Bridge in the background. This stone bridge was replaced in 1963 after it was declared unsafe. Travel on the River Ouse at St Neots these days is slightly less innovative.

54

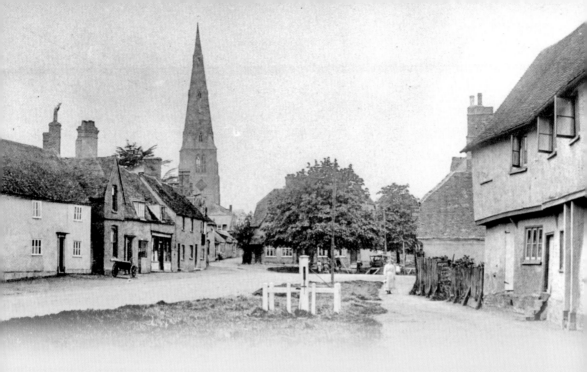

Part Two

The Villages

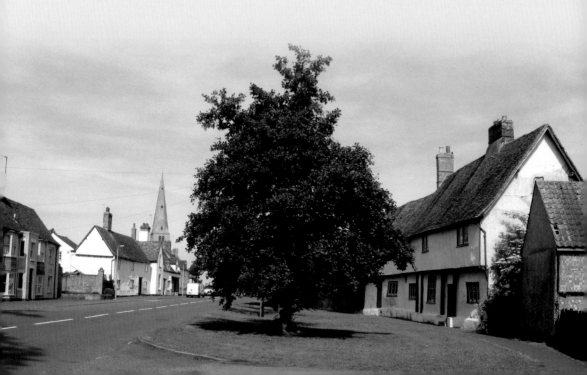

Alconbury

Alconbury brook is a tributary of the River Ouse which runs through the centre of Alconbury. The long narrow green on either side dates from medieval times. The brook is spanned by two bridges, the old stone road bridge in the north and a footbridge next to the ford in the south. The measuring post next to the bridge records the levels of the brook during its regular floods.

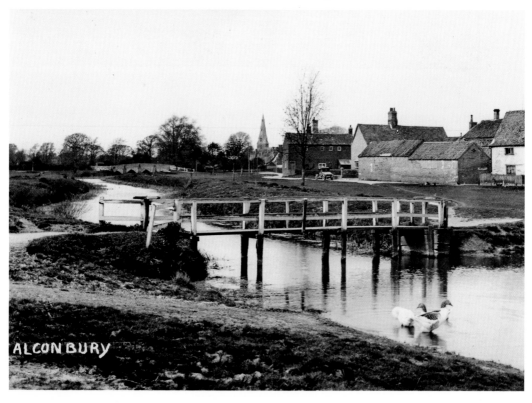

ALCONBURY

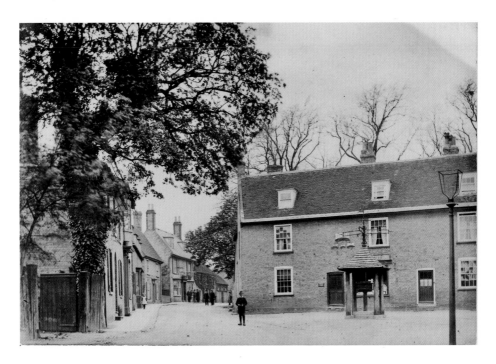

Bluntisham – Block Hill

Block Hill is the former centre of commercial activity in Bluntisham, with a general store, post office and reading room. It was once the location for the Bluntisham Feast, a religious festival commemorating St Ethelreda. The barograph memorial was built in 1911 in memory of Charles and Mary Tebbutt by their son Louis. A barograph is an instrument for measuring and recording atmospheric pressure.

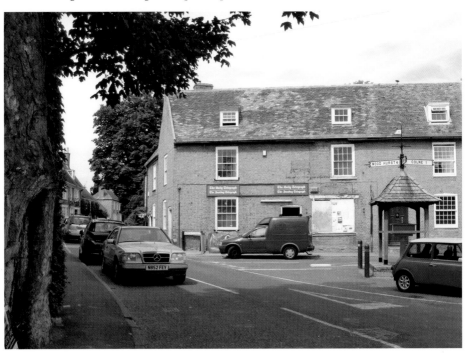

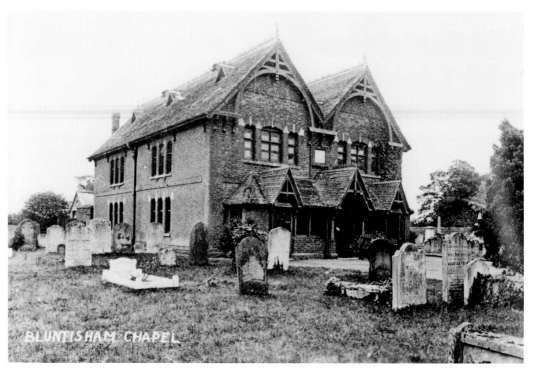

Bluntisham Meeting House
The Baptist and Congregational Union Meeting House was built in 1787, founded by Coxe Feary who became Pastor for thirty-five years. It was rebuilt in 1874. There was a schoolroom and burial ground attached. It is still in use as a chapel.

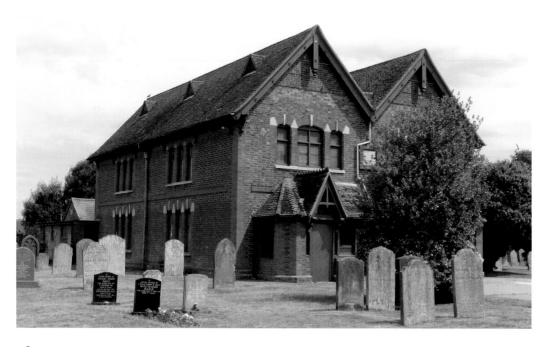

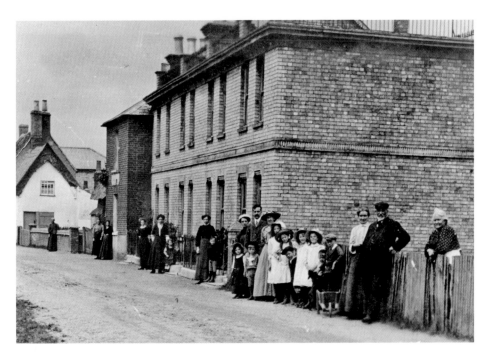

Brampton – West End
Previously known as Marsh Lane, West End, as its name suggests, is situated at the western end of the village. The houses here have changed little over the last hundred years.

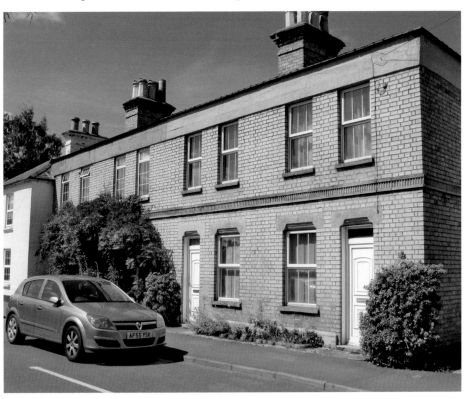

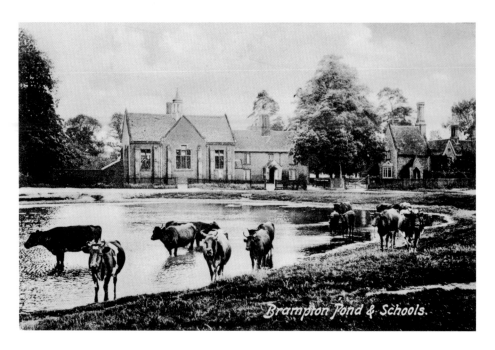

Brampton Pond & Schools.

Brampton Green

Brampton pond was fed by a spring. Eventually it dried up and the pond was filled in to make Brampton Green. Many of the trees on the Green were planted to celebrate Queen Victoria's Jubilee. The old school was built in 1843 with funds provided by local philanthropist Lady Olivia Bernard Sparrow. The building is still part of Brampton Junior School, although the buildings next to it have made way for an infant school, built in 1964.

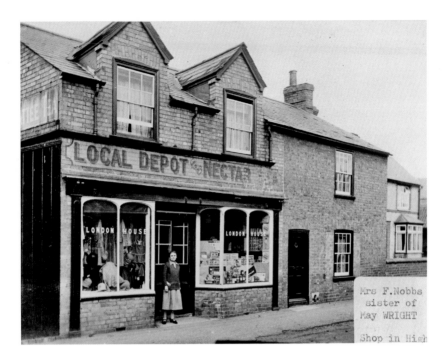

Brampton – High Street

London House in Brampton High Street was one of two shops owned by William Wright in the early 1900s. William Wright, a parish councillor for thirty years, was a prominent non-conformist. His wife laid one of the foundation stones of the Methodist church. The lady in the doorway is Flora Nobbs. She and her husband Arthur took over the shop from the Wrights. London House has continued as a shop; until recently it was Childs greengrocer's. It is now a gift shop.

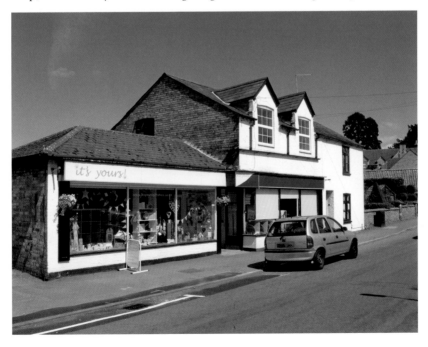

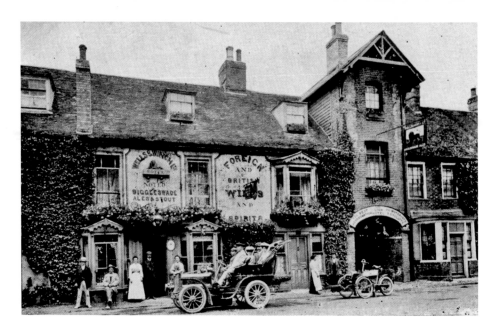

Buckden – the Lion Hotel

Although it looks quite modern, the Lion Hotel dates from the fifteenth century. The original part of the inn is timber framed, but is incorporated within the white painted brick building, extended in the eighteenth century. Over the years it has been called 'The Lion and Pennant' and 'The Lion and Lamb', but has reverted to its original name 'The Lion'. The old photograph, taken in 1900, shows an early open 'tourer' car and delivery bicycles.

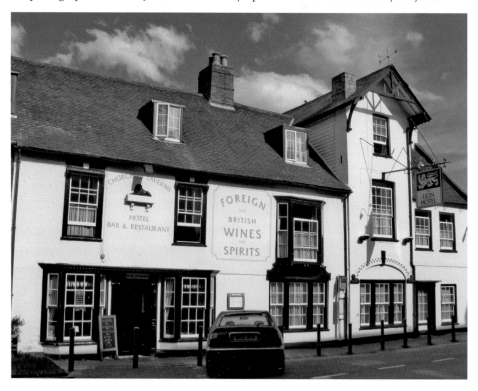

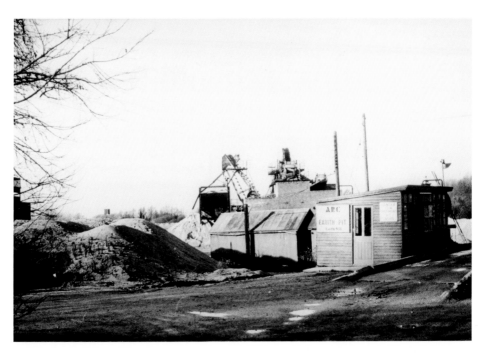

Earith Pit

Earith pit in Meadow Drove is situated on rich deposits of sand and gravel which used to be in great demand by the construction industry. The pit is now closed and has been replaced by fishing lakes.

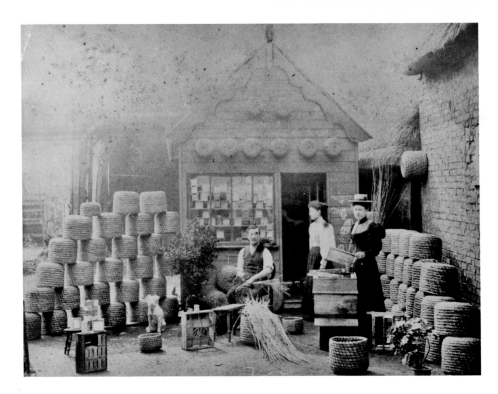

Earith Businesses

When this photograph was taken in 1911, there were around twenty small businesses in Earith High Street. Beehive maker Fred Seamark was one of a family of craftsmen – Richard Seamark was a thatcher and George Seamark a cycle maker. Now only the post office remains in the centre of Earith; businesses have relocated onto the Earith Business Park on Meadow Drove.

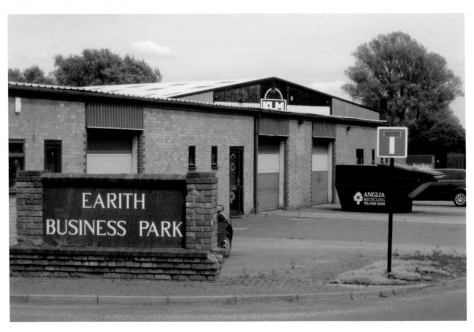

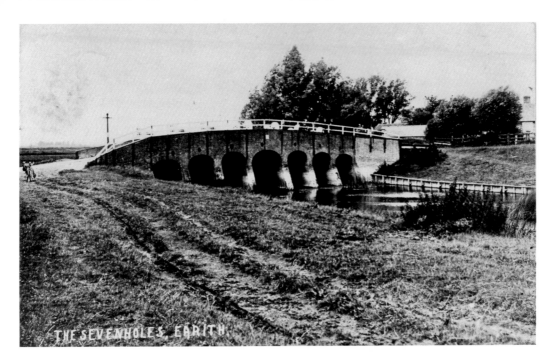

Earith – Seven Holes Bridge

The Seven Holes Bridge replaced a nine hole bridge over the Old Bedford River, probably first built in the 1630s. The bridge in the old photograph was built by the Hundred Foot Wash Commissioners in 1824. The palisading was erected by Tom Benton after his pony and trap went into the river in 1928. The Seven Holes Bridge has itself now been replaced.

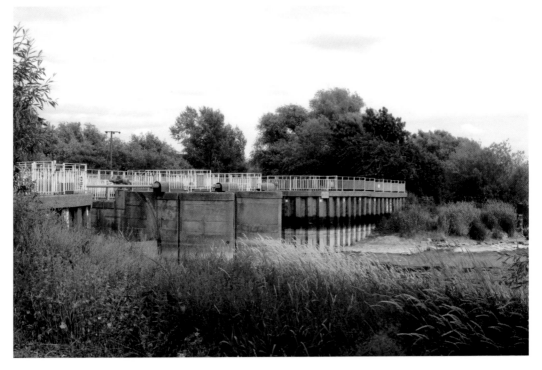

Eaton Socon – St Mary's Church
In just two hours, in February 1930, over eight centuries of history were destroyed when St Mary's church was almost completely destroyed by fire. Just over two years later, the church had been rebuilt and was back in use.

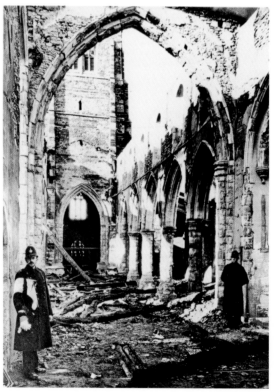

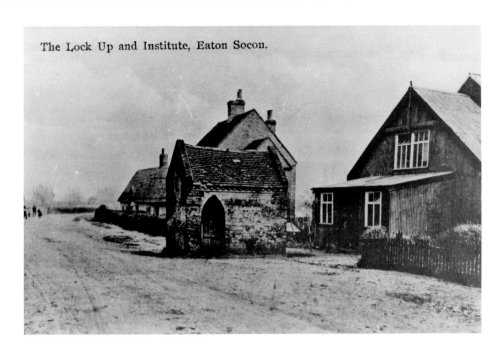

The Lock Up and Institute, Eaton Socon.

Eaton Socon – the Cage

One of only a few village lock-ups surviving in the area which predate the formation of the police force, it is known locally as 'the cage'; it was built around 1826 to hold criminals before they were sent to court in Bedford. At one time, there was a fire engine house adjoining the lock-up. Many wanted to demolish both to give better access to the Institute behind it, but it was restored in 1963.

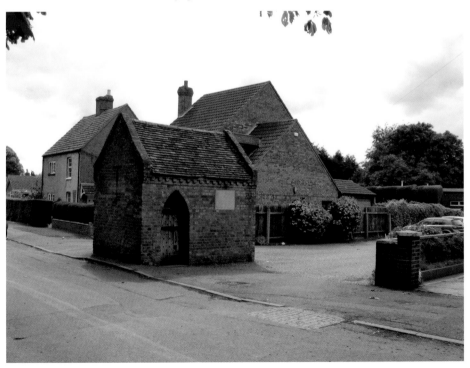

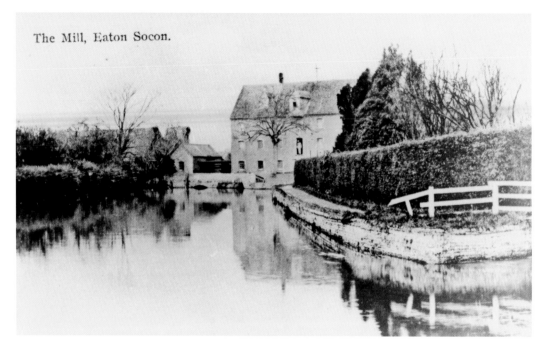

The Mill, Eaton Socon.

Eaton Socon Mill

There has been a mill on this site for centuries, but the current building dates from 1847. As the mill fell into disuse in the 1960s, a garden centre and then housing developments took over the areas previously used for warehouses. The mill itself was converted into an inn in the early 1980s and is now known as the Rivermill Tavern.

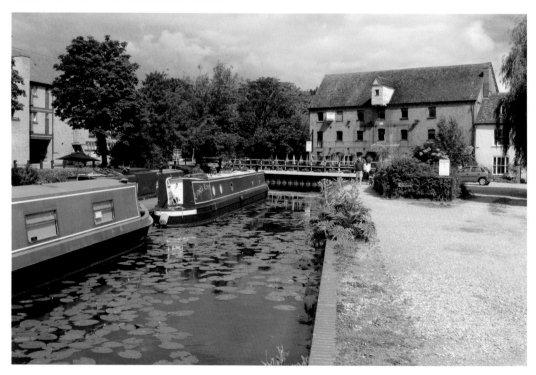

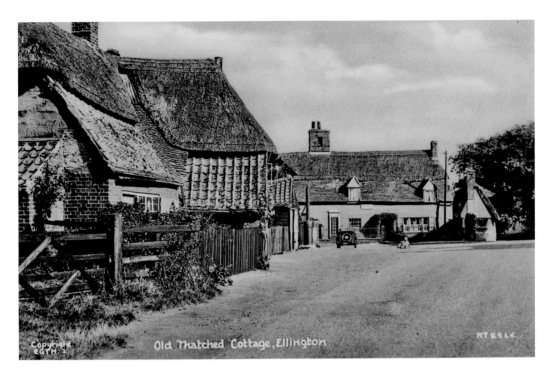

Old Thatched Cottage, Ellington

Ellington

Ellington was once on the main road from Huntingdon to Thrapston, with traffic thundering through the village. Once the bypass was built the village became peaceful once more. The old cottage in this photograph was later demolished.

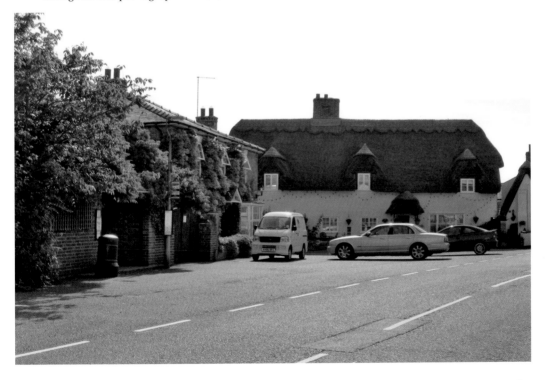

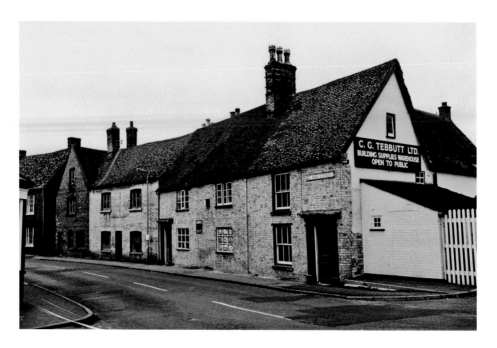

Eynesbury

The old photograph of Church Street shows the Village Blacksmith public house with a sign advertising C. G. Tebbutt Ltd. Now a private house, it is located next to a former wharf and fellmongers yard near to the Brook. This was occupied during the First World War when soldiers of the Fife and Forfar Yeomanry were billeted here for a time. In 1915/16, the yard became Tebbutt's joinery workshop and store. It is now a housing development named Navigation Wharf.

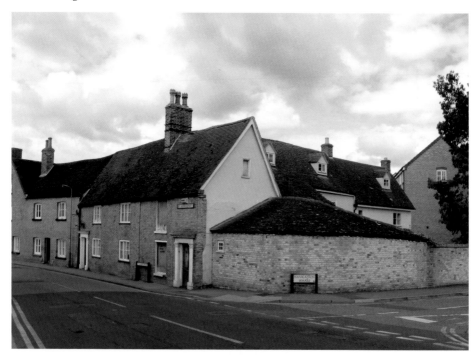

Fenstanton – Low Road

The Great Ouse forms the northern boundary of Fenstanton parish. Boats have been using it since medieval times. The old photograph is of William Hookham, a Lighterman in the Low Road between St Ives and Fenstanton, taken around 1900. These days, commercial activity in the area has given way to pleasure boating. Jones Boatyard was established in Low Road in 1946.

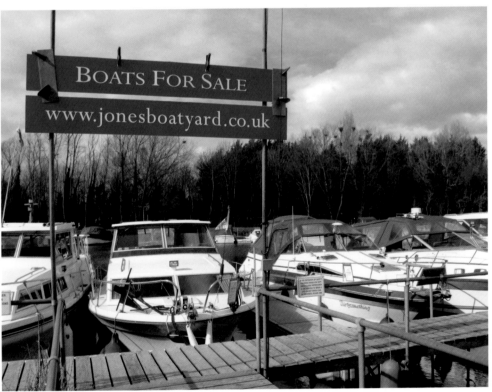

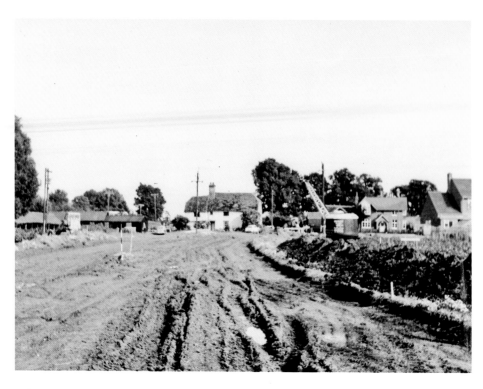

Fenstanton – Oxholme Farm

The earlier picture shows Oxholme Farm during the early stage of the bypass construction in 1964. The building of the road which became the A14 cut these houses off from the rest of Fenstanton which now is accessible only via an underpass.

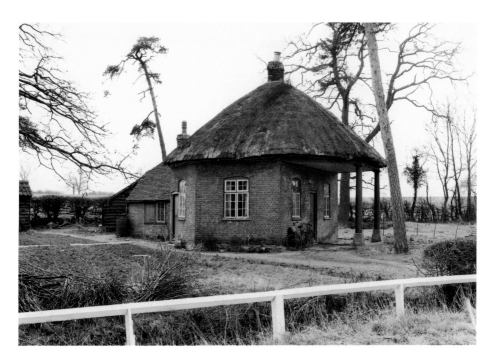

Grafham

Fifty years ago, what is now Grafham Water was a collection of rural farms and houses. The old photograph shows one of them named Round Lodge, in 1962, when construction began on the new reservoir. Grafham Water was officially opened by Prince Philip in July 1966. Holding up to 13,000 million gallons of water, the lake not only provides water supplies for the surrounding area, but is also a popular spot for fishing, sailing, walking and cycling.

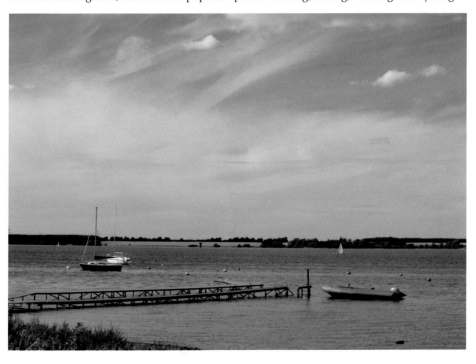

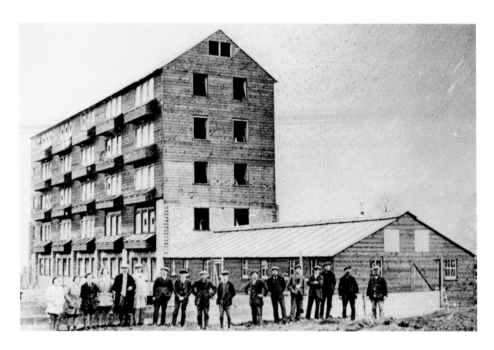

Great Paxton Hill

Built in 1924/25 next to Paxton Hill House, the New Titan Works was an intensive poultry farm. The building was later used as a rabbit fur farm. Both ventures were short lived and the building stood empty until the Second World War when it became the Harley Works, making aircraft landing lamps. The whole building was eventually demolished and the site has become a small industrial park.

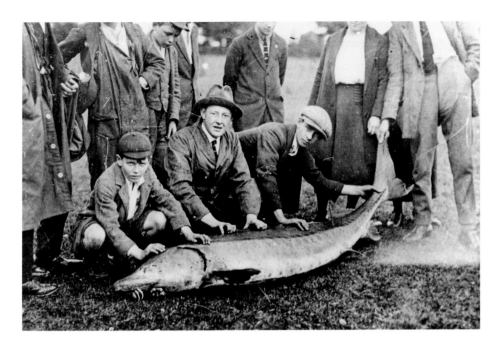

Hemingford's Mill Pool

In 1907, between 1,500 and 3,000 people gathered to watch an attempt to catch a huge sturgeon which had been spotted in Hemingford mill pool. The plan was to cut the giant fish into steaks and sell them in aid of the County Hospital, but the attempt failed. The sturgeon was not caught until 5 August 1924. It was eight and a half feet long and weighed 185 pounds. Those fishing in the twenty-first century can expect slightly less impressive catches.

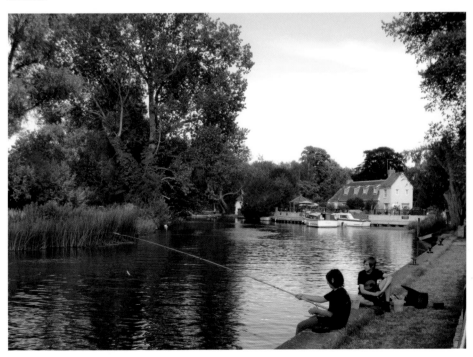

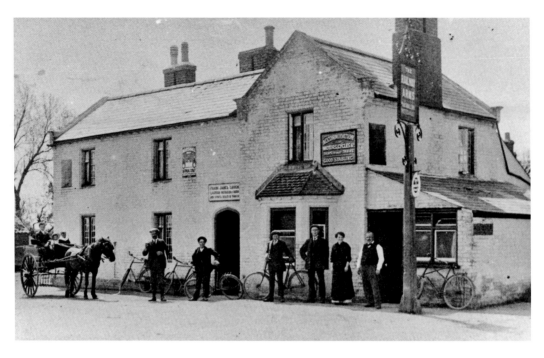

Holme – Railway Arms

The Railway Arms Inn, *c.* 1915. The Railway Arms was situated between the village of Holme and the railway line. It is now a private dwelling named Pingle Bank House.

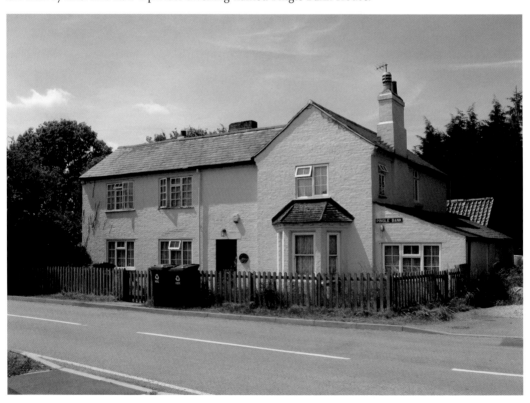

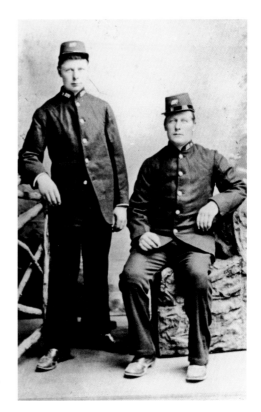

Holme Postmen

William and Walter Burdett were postmen in Holme in the early 1900s. At that time, there were three postal deliveries a day and a post office to send mail and telegrams. Holme post office closed in June 2009 and was replaced by a mobile post office calling four times a week.

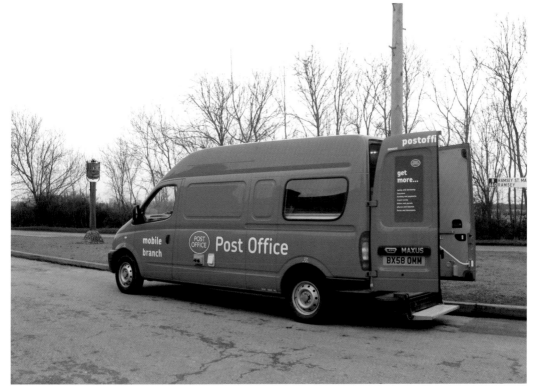

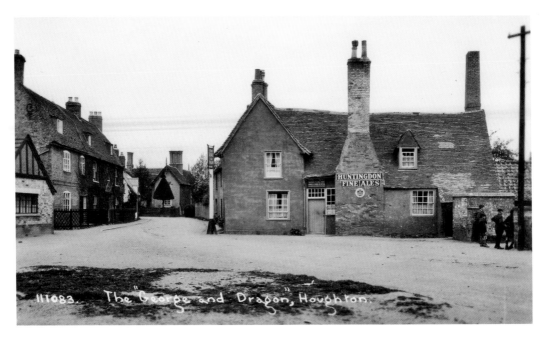

Houghton Green

The photographs show the oldest surviving building in Houghton village, dating from the fifteenth century. It was originally a yeoman farmer's house, but later became the George and Dragon public house. Today, it has reverted to being a private residence.

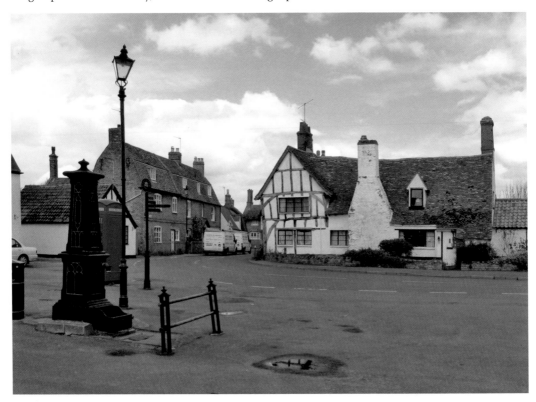

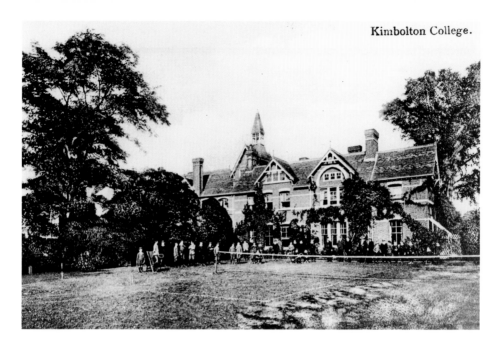

Kimbolton College.

Kimbolton College

This photograph, pre-1914, shows the grammar school building designed by the well known Huntingdonshire architect Sidney Inskip Ladds. Kimbolton School moved to the Castle in 1950 and this building is now the headmaster Mr Belbin's house, adjacent to the Kimbolton Preparatory School.

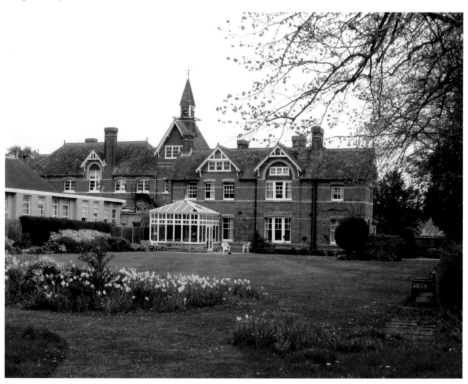

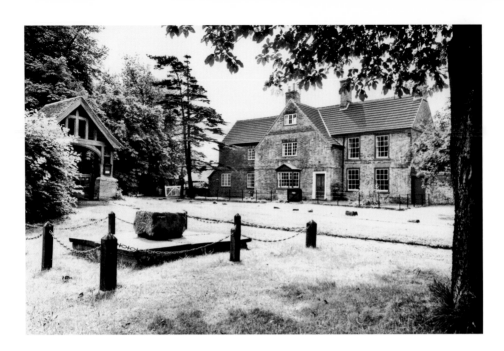

The Leighton Stone

At the time of Domesday, Huntingdonshire was divided into four 'hundreds'. A hundred was an Anglo Saxon measurement of land for tax purposes. Leightonstone hundred was the one which covered the west of the county. Hundred courts met to settle local disputes, usually at a fairly remote place at the centre of the hundred marked by a 'hundred stone'. Today, the stone stands outside Leighton Bromswold church.

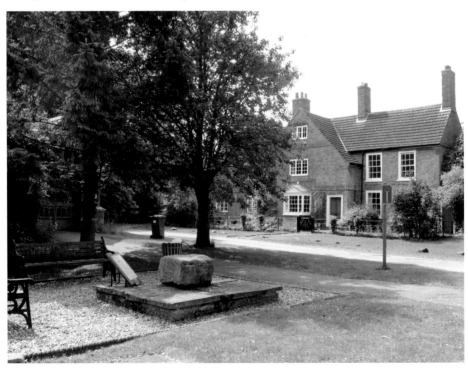

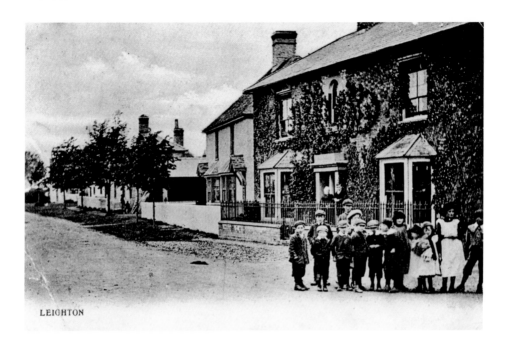

LEIGHTON

Leighton Bromswold – The Avenue

The name Leighton Bromswold means 'clearing in the Bromswold Forest'. There is very little forest that remains today and the village sits on a ridge overlooking the Vale of Spaldwick. Leighton Bromswold is made up largely of one long main street. This house in The Avenue is opposite the Green Man public house.

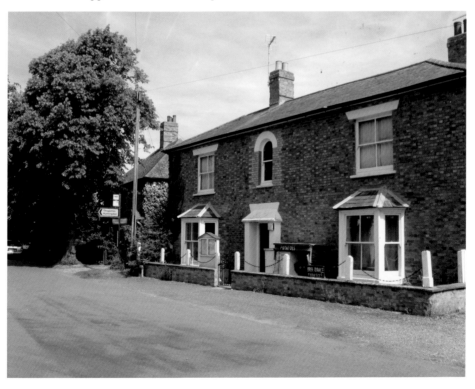

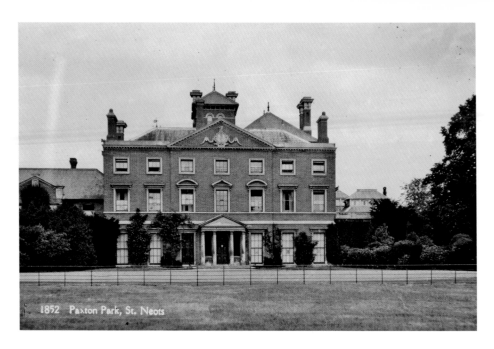

1852 Paxton Park, St. Neots

Paxton Park

Paxton Park was built in the 1750s, set in extensive open parkland. The house was sold in 1920 and used as a Christian Science Boarding School until 1937. During the Second World War, the building was requisitioned and used as a maternity hospital for women from London. The hospital closed in 1955, the house was demolished and the area used for housing development.

PARK DRIVE

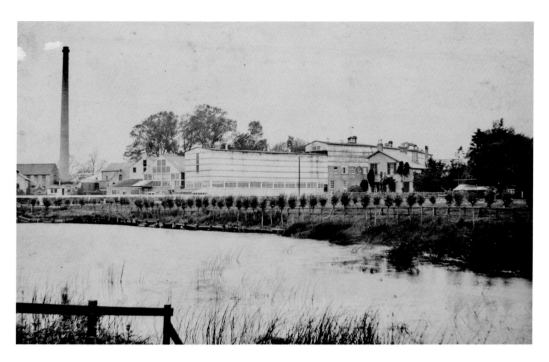

Little Paxton Paper Mill
There has been a mill at this site since Norman times and a paper mill was built here in 1799. The older photograph was taken before a disastrous fire in 1912. Despite this and various closures, the paper mill kept going until the 1980s, most recently run by Samuel Jones Ltd. Industrial activity here has now ceased and a large housing development has taken over the site.

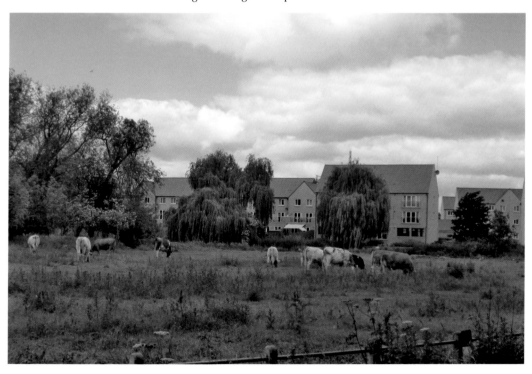

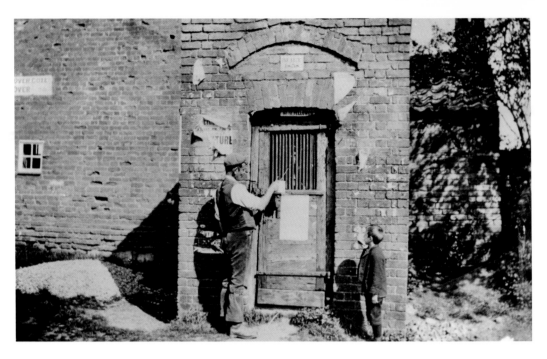

Needingworth Lock-up

The Needingworth lock-up was built in 1838 and was used by the Parish Constables to restrain drunkards and wrongdoers until they could be conveyed to the local Police Station or prison. The boy in the old photograph, in 1910, is Ebenezer Campling. The board next to the lock-up is a roll of honour to those from the village who gave their lives in the world wars.

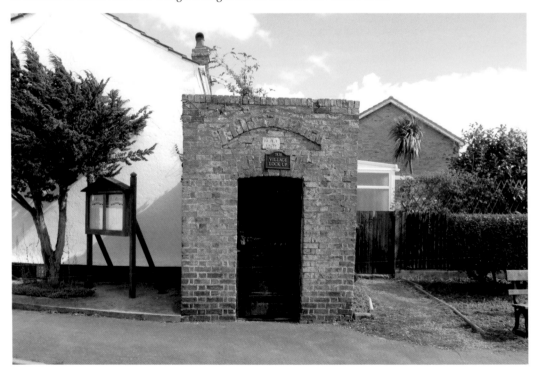

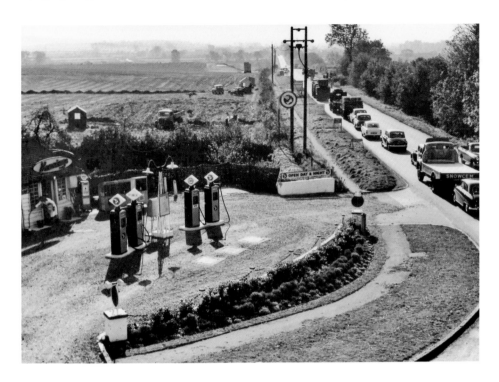

Norman Cross

This photograph shows the Great North Road as it was before 1958 when the construction of the Stilton bypass created a dual carriageway road leading to a large roundabout. A further upgrade in 1998 to what was now known as the A1 removed the roundabout and the road became a four lane motorway.

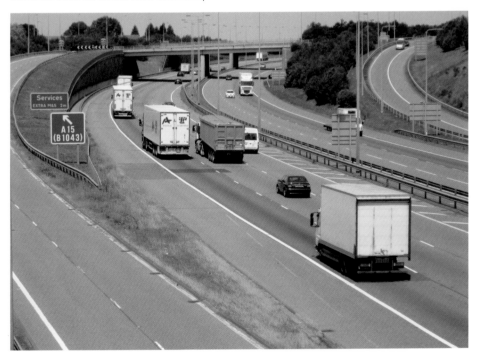

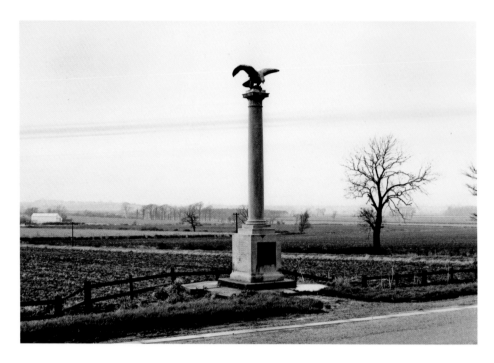

Norman Cross Napoleonic Monument

The old photograph shows the original monument which stood next to the Great North Road. It was erected by the Entente Cordiale Society in 1914 in memory of the Napoleonic soldiers and sailors who died in the nearby prisoner of war camp. The monument was vandalised and the eagle stolen in 1990 and was taken away completely when the A1 was upgraded. A new monument was commissioned and unveiled at Norman Cross in 2005.

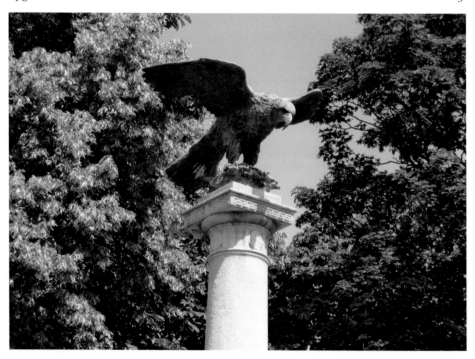

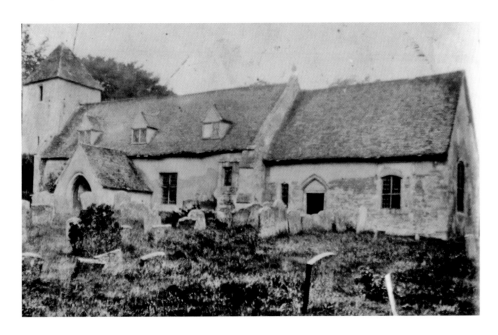

Sawtry – St Andrews Church

Until the year 1880 there were two churches in Sawtry, All Saints and St Andrews, but both were demolished in that year and the materials used in the erection of a new church of All Saints. Today, the old churchyard of St Andrews lies neglected alongside the A1 motorway, although a modern St Andrews cemetery next to it marks its location. It contains many interesting gravestones, including a slate slab commemorating a Leicestershire man killed in a duel with his best friend in 1756.

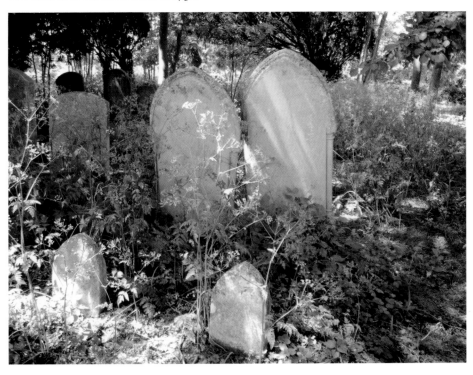

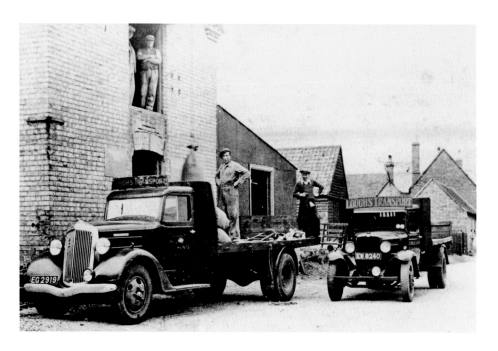

Sawtry – Green End Road

Robert Turnill ran his corn merchant business from these premises in Green End Road from around 1890 to the early 1940s. This photograph, from around 1940, shows sacks of grain being delivered by Loughs Transport of Holme. The man in the overalls on the front lorry is Sidney Woollard, a Sawtry man, who later lost his life in the D-Day landings. The mill is now a private house.

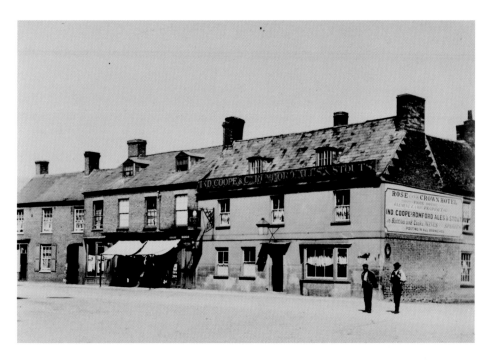

Somersham – Rose and Crown Hotel

The Rose and Crown Hotel is still in business as a public house. To the left of the picture is Bonnetts bakery, the oldest established retail business in Huntingdonshire, operating since 1803.

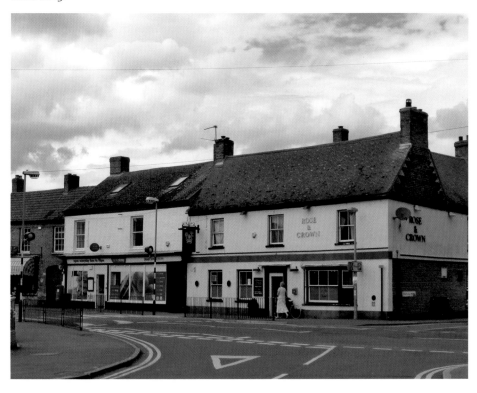

Somersham – The George

Situated at Somersham Cross, the George is a former coaching inn, one of around thirty public houses in Somersham from the 1600s. It is still in use as a pub. The modern photograph shows the bus shelter built in 2000.

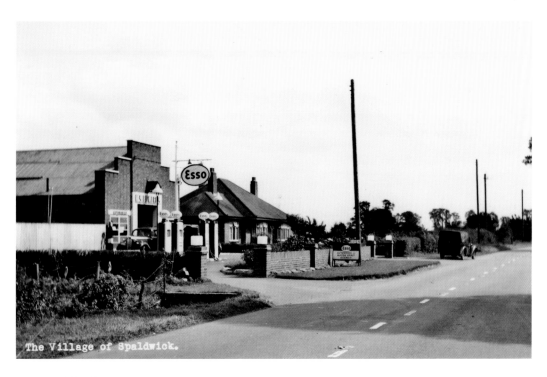

The Village of Spaldwick.

Spaldwick Garage

As these two photographs show, there has been a garage in Spaldwick for many years, although the garage and the house next to it have swapped places! Fortunately for business, the garage was not bypassed with the rest of the village when the A1/M1 link road opened in 1994.

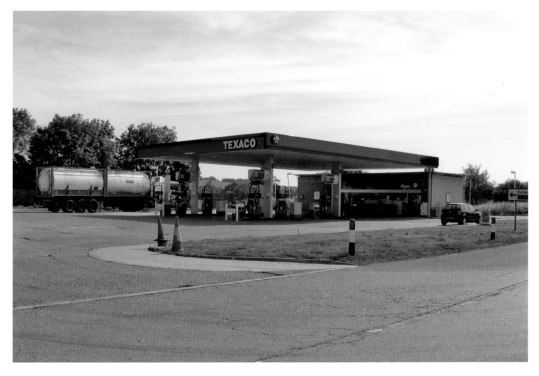

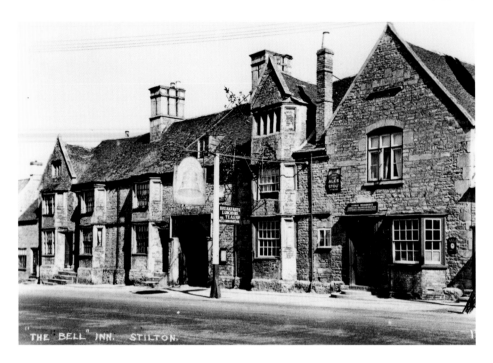

Stilton – the Bell Inn

The Bell Inn dates back to at least 1500 and is probably older than this. The wrought iron sign is a replica of the original, made by a Somerset blacksmith as part of a complete refurbishment carried out in 1983. The old sign was so heavy it needed a prop standing in the road to hold it up. The Bell Inn is closely associated with the stilton cheese which was made here and popularised by the landlord Cooper Thornhill in the 1730s.

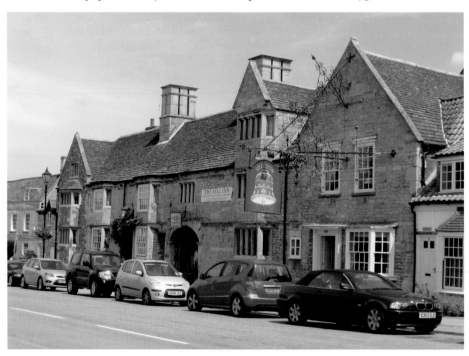

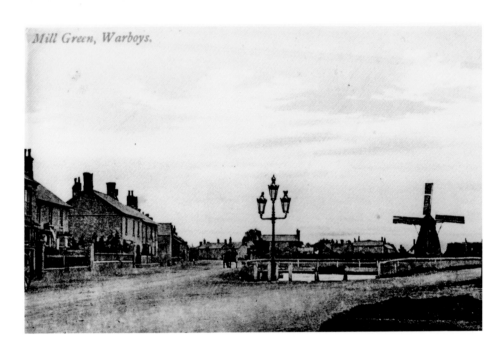

Mill Green, Warboys.

Warboys Mill Green

The old view looking towards the pond, known as the Weir, shows Warboys windmill which has since been demolished. The pond and the unusual three globed lamp remain though. The lamp was originally erected in 1897 for Queen Victoria's Diamond Jubilee. Over the years it sank into the ground and lost its lamps, but it was refurbished in 2000.

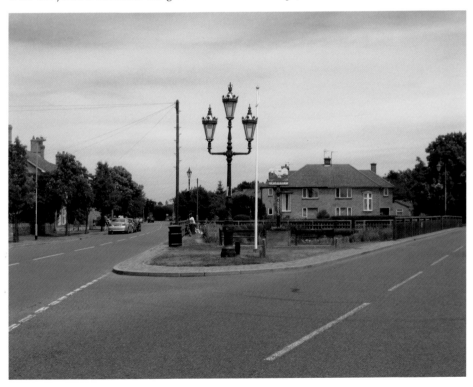

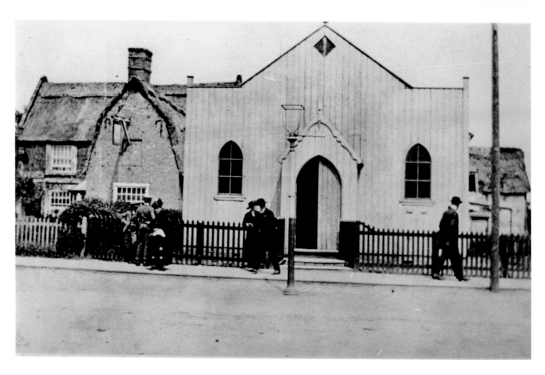

Warboys Methodist Chapel

The White Hart dates from the seventeenth century and is still in use as a pub, having been refurbished after a fire in 1996. The chapel next to it was originally built of wood, but was replaced by a brick built chapel which was moved brick by brick from Great Raveley.

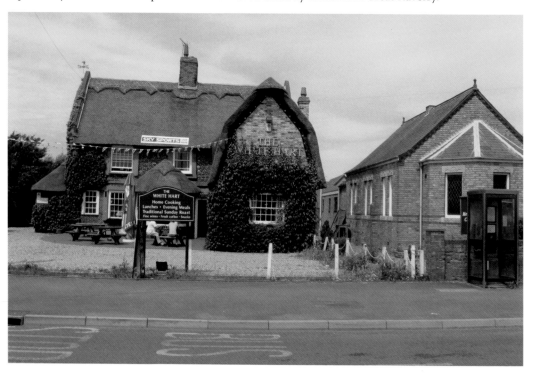

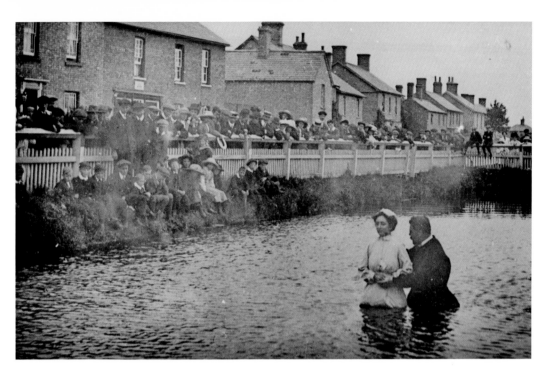

Public Baptism

The Warboys Baptists practiced adult baptism, which involved full immersion in the Weir. It was a popular spectacle and around two or three thousand people from across the county would surround the pond to watch. This whole area was refurbished for the millennium.

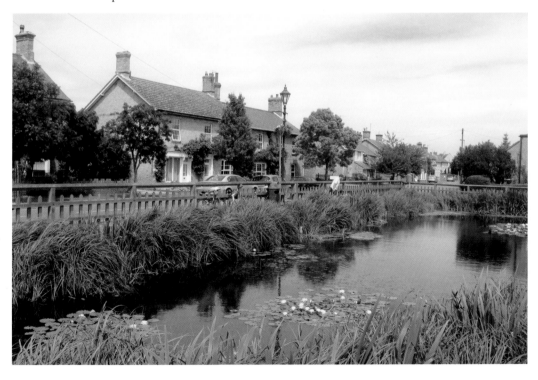

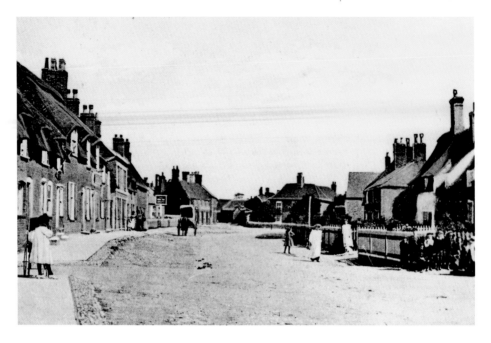

Yaxley Main Street

Main Street Yaxley is part of the old village which at one time belonged to the Benedictine monastery of Thorney. Before the draining of the Fens, this lower area served as a port on Whittlesea Mere. The name Yaxley means a 'clearing where cuckoos congregated', but large scale expansion of Yaxley as a Key Rural Settlement means there are few cuckoos around here these days.